PICASSO

PICASSO

by
Danièle Boone

BRACKEN BOOKS

LONDON

Originally published by Fernand Hazan, Paris 1989

Translation into English by John Greaves

This edition published 1989 by Bracken Books
a division of Bestseller Publications Ltd
Princess House, 50 Eastcastle Street
London W1N 7AP, England

ISBN 1 85170 251 2

Printed and bound in Hong Kong

Dedication : to Tanguy and Julia.

Acknowledgements: The author wishes to thank, in particular, Marie-Laure Bernadac, Curator of the Picasso
Museum in Paris, for her invaluable assistance and Annie Dufour for her kindness.

INTRODUCTION

Pablo Ruiz Picasso was born on 25th October 1881, in a large white house in Málaga, southern Spain. In the Iberian tradition, he was christened Ruiz, his father's name, and Picasso, after his mother. Jaime Sabartés, Picasso's companion during his adolescent years in Barcelona, was to recall that: 'His Catalan friends got into the habit of calling him by his mother's name, his father's being commonplace, and Picasso by its very foreignness was deemed more fitting for a being who so markedly stood out from his fellows.' His father, José Ruiz Blasco, was a painter. He used to paint the pigeons which thronged in the plane-trees in the Plaza de la Merced, which the family house overlooked. Occasionally, he would ask his son to finish off his paintings for him. Legend has it that one day Don José, examining the completed work, found it so alive and vital that he promptly handed over his palette and brushes to his son, declaring that his talent was now mature, greater than his own, and that, for his part, he would never paint again. Picasso was 13 years old.

This handing-down of paint-brushes from father to son is reminiscent of a ceremony familiar to every Spanish schoolboy – the 'initiation', the moment when the apprentice toreador becomes a fully fledged matador. The bullfight played an important part in Picasso's life. In every Spanish town the arena is the focus for popular entertainment. In Málaga, the bullring is close enough to the southern slopes of the citadel to allow those without tickets to watch from the distance. As a child, Picasso was taken there by his father, who appreciated the smallest details and took pleasure in explaining the subtleties of the combat to his son. Picasso's childhood drawings often represented scenes from the bullfight. His earliest preserved work, an oil on wood painted at the age of 8, is called *The Picador*. Picasso kept this work throughout his life, taking it with him every time he moved house. His passion for the bullfight never diminished. He made ritual visits every year and the 'corrida' continued to make regular appearances in his work.

THE APPRENTICESHIP YEARS

Picasso spent a modest childhood in Málaga. Don José supported his family by working as curator of the municipal museum and as a restorer of paintings. Pablo, none the less, lived the childhood of a little prince so typical of the Mediterranean tradition. María Picasso Lopez, his mother, was small with a delicate complexion. Her son took after her. We know little about her except that she seems to have had a stronger personality than her husband. Picasso always had great respect and tenderness for her, and when he definitively adopted her name, it was his way of ridding himself of paternal influence and of thanking her for her unflagging belief in him. With the arrival of two daughters, Concepción and Lola, Don José was obliged to recognize that he was fighting a losing battle in his efforts to provide for his family's needs. In 1891 he decided to accept a post as drawing teacher at a college in La Coruña, in north-west Spain. He detested the town on sight and some months after their arrival, as if to confirm his hatred of the place, Concepción died of diphtheria.

Picasso found himself projected into another world, a new environment, which enabled him to consider things relatively and make comparisons. Thanks to his father's position at the college, he was able to spend his time drawing, painting and learning in the most friendly and protected atmosphere. He applied himself with such vigour that, in a very short time, he had mastered

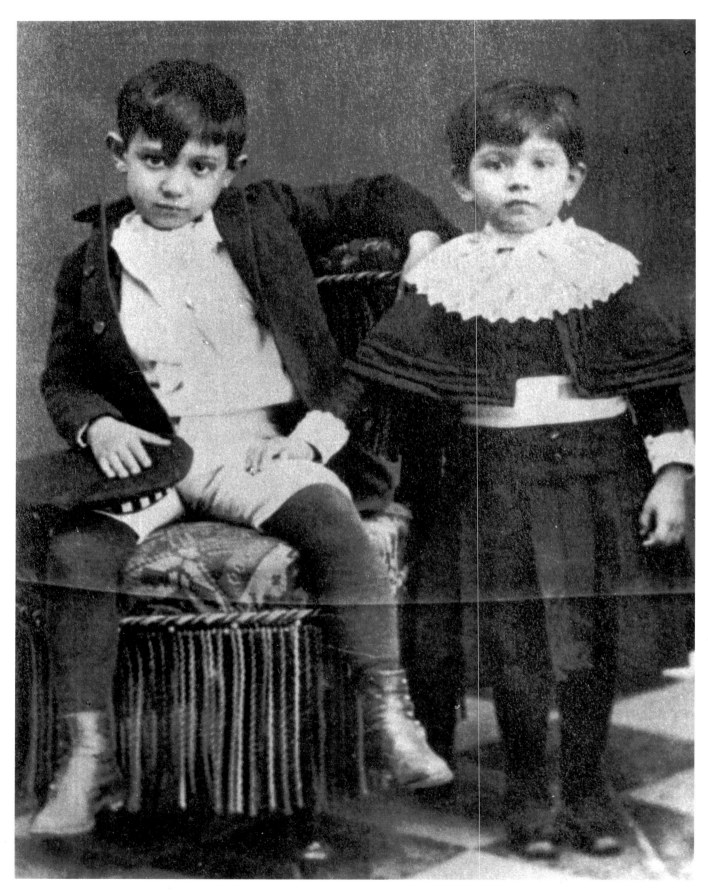

Picasso and his sister Lola in 1888.

academic charcoal technique, which concentrated on achieving relief by means of light and shade. Later he was to say, 'I never drew like a child. When I was 12 I drew like Raphael.' On an academic level, however, he was less than brilliant. The rudimentary 'three Rs' presented insurmountable problems. Happily for Picasso, Don José, convinced of his son's gift as a painter, did not insist on this aspect of study.

Picasso drew incessantly, not only the academic drawings his apprenticeship required of him, but also sketches of people and things he saw around him: fishing boats in the port, bourgeois families on the beach, the landscapes around the Hercules tower which dominated the town from its rocky promontory. Above all, he loved to draw his sister, Lola, who remained his favourite model. Bored by the idea of writing letters to his family in Málaga, he conceived a tiny illustrated magazine for which he was editor, director, illustrator and sole reporter. He gave his paper titles like *La Coruña* (The Crown) or *Azul y Blanco* (Blue and White). Many of the portraits and caricatures to be found in these pages are extraordinarily accomplished. The layout, the choice of lettering, the quality of the texts and the humour in the headlines are early evidence of a luminous personality. Throughout his life Picasso continued to pepper his correspondence with drawings.

In the spring of 1895, Don José was appointed professor at La Lonja, the Fine Arts college in Barcelona, though he left his family in La Coruña so that Pablo could finish the La Coruña school year. That summer, the holidays were spent in Málaga. On the way, Picasso and his father paid a visit to the Prado where he encountered Velázquez, Zurbarán and Goya for the first time. In this period, reproductions of works of art could only be achieved by means of engravings or lithographs. The finer details of an artist's technique or his use of colour could only be appreciated in museums.

In Málaga, Picasso's uncle, Salvador Ruiz Blasco sought a way in which to exploit his nephew's talents. He secretly hoped that the young artist's reputation would reflect on the whole family. He began by offering a wage

La Coruña, *16th September 1894.*

of five pesetas a day in return for the execution of several portraits. The first was a study of an old sailor in his uncle's charge and it was great success. It leads in direct succession to Picasso's first major canvases, *The First Communion* exhibited in 1896 and *Science and Charity* shown for the first time at the National Exhibition of 1897. At first, his nephew's rapidity of execution disturbed uncle Salvador. Picasso reappeared some days later with a second portrait, this time of his aunt Pepa. Pablo much preferred playing with his sister and his cousins. He could entertain them endlessly, bringing to

life with astonishing speed images of people, birds and animals, anything they asked for. Much later, he was to amuse himself even more by drawing in reverse in such a manner that the person sitting opposite him could watch his portrait emerge the right way round!

When Picasso arrived in Barcelona, he was barely 14. Although he was under the required age, on the insistence of his father, he was allowed to forgo the tedious preparatory courses at La Lonja and sit the entrance examination to the upper school. In one day he completed the exam for which the officially allocated time was one month. His astonished examiners recognized him as a prodigy. The drawings for this examination are still in existence. His undeniable technical skill paid no lip-service to the canons governing the proportions of the human body then in practice; he simply reproduced what he saw with the utmost fidelity. Picasso never lost this rigorousness of vision. Speaking of his Cubist portraits, all his models have told of the long hours of posing to which they were subjected, during which Picasso scrutinized them in minute detail.

Don José, always concerned with his son's progress, soon found him a studio close to the family home. For the first time he had a room in which he could work without being disturbed. Here he spent many hours painting portraits of his friend, Manuel Pallarès, another painter from La Lonja. They would talk together about their respective work; Pallarès had become Picasso's guide to Barcelona. At the end of the nineteenth century, the city was already an important artistic centre, a gateway to the north and east. Ibsen was widely read and his plays were performed in Barcelona's theatres. The operas of Wagner, the music of César Franck, the painting of Puvis de Chavanne were all appreciated in the city. There was a sense of the importance of artistic values absent, for instance, from Madrid. Two paintings by El Greco,

recently acquired in Paris, were carried in a ceremonial procession through the streets, escorted by Catalan poets and painters, and installed in the local museum. Picasso fell in love with the town immediately. He stayed there for nine years, interrupted only by occasional trips to Madrid and Paris.

SELF-CONQUEST

Picasso soon realized that he had to escape the influences of the school and its academism, and also the influence of his father. He decided to leave for Madrid where he won a scholarship to the Royal Academy but, before very long, he was 'forgetting' to go to school. His real teachers were at the Prado. 'Velázquez is first rate,' he wrote to Bas, one of his colleagues at La Lonja. 'There are some magnificent El Greco heads. Murillo is not always convincing. Titian's *La Dolorosa* is good; there are some beautiful Van Dyck portraits; in Rubens there are snakes of fire.' When his father learned that he had left the academy, he cut off his allowance. For the first time, Picasso was alone and penniless. Without wood for heating, with little to fill his stomach, he worked incessantly, spurred on by his new-found independence. But the Madrid winter was unrelenting. A severe dose of scarlet fever brought him back to Barcelona.

Shortly afterwards, he left with his friend Pallarès for Horta. 'Everything I know, I learned in Pallarès' village,' he often reiterated. It is true that, during this eight-month period, he discovered virgin territory to explore: peasant scenes, local houses, interiors with hand-carts and wine-presses, mountain landscapes. Above all he was able to distance himself from his experiences in Madrid. These moments of breaking away and reassimilation were always essential to Picasso. Horta had become his place of

refuge. He returned there at the time of the decisive turning-point in his painting towards Cubism in the spring of 1909. The unaffected 'realness' of Horta enabled him to solve the problems of changes in direction which he set himself in Paris.

The 18-year-old Picasso who came back to Barcelona in February 1899 had matured considerably. The independence he had so desired before he left for Madrid was now complete. He no longer lived with his family but shared a studio with one of his fellow-students, Joseph Cardona. The year before, Spain had gone to war with the United States over the Cuban issue. More than by the war itself, young Catalan intellectuals were troubled by their country's defeat. Picasso met those who called themselves the 'Generation of 98': Santiago Rusiñol and Joan Maragall. He quickly established a leading position among his companions; Jaime Sabartés, Ramon Pitxot, Sebastià Junyer, Carlos Casagemas, largely due to his charismatic personality. 'There was nothing very seductive about him when you didn't really know him,' Fernande Olivier said later, 'nevertheless, his strange insistent look demanded your attention. You could not quite situate him socially, but this radiance, this inner fire that you felt in him gave off a kind of magnetism . . . ' Brassaï, another close observer, speaks of a man who is 'simple, without affectation, without arrogance', but who can fascinate you with his 'smouldering, jet-black eyes' like 'black diamonds'. These extraordinary eyes dominate his self-portraits. Even though, as Brassaï emphasized, 'contrary to what is said about him . . . they are neither abnormally large nor abnormally dark. If they appear to be enormous, it is because they have the curious ability to open really wide, revealing the white sclerotic . . . creating flashes of reflected light . . . The eyes of a visual being, born to be perpetually astonished.' In fact, for Picasso, only things seen constituted knowledge and understanding; inevitably he had the look of someone who is constantly awake; he scrutinized objects and expressions. His need to transcribe them haunted him all his life. Up until the very end he struggled, with a prodigious vitality,

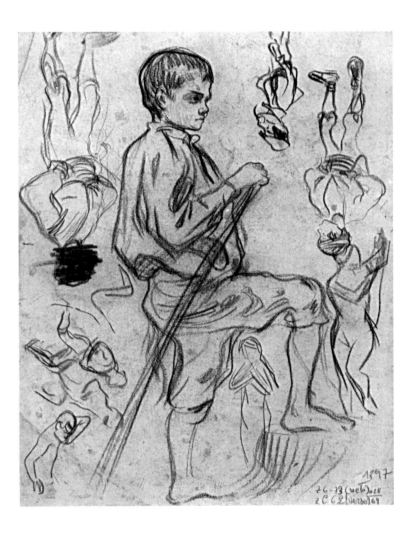

Young Boy Leaning on a Stick and Studies, *1897.*

to express things as they are, to express everything that a human being can know at every moment of his existence.

In February 1900, he exhibited several portraits, including brush-painted caricatures and realist charcoal

drawings at El Quatre Gats. This artistic and literary tavern, which had opened two years earlier, modelled itself on the style of the Parisian cabaret Le Chat Noir. A stone's throw away from the Barrio Chino, the old quarter of Barcelona, where artists, political rebels, poets and vagabonds lived by night, Els Quatre Gats had become an exclusive rendezvous for all Catalan intellectuals. Three weeks later, Picasso, under his legal name, Pablo Ruiz, entered a competition from which works would be selected to be sent to the Universal Exhibition in Paris. His canvas entitled *The Last Moments* was chosen. Having decided to accompany his work to the French capital, in October he left Barcelona with his friend Carlos Casagemas.

Paris meant freedom, beautiful women, the heady perfume of *La Bohème*. Picasso installed himself in Montmartre. He devoured every single retrospective in the Great Exhibition. He visited the Louvre and the Luxembourg, he discovered Ingres and Delacroix. He frequented the painters' galleries, Ambroise Vollard's in particular. He saw the works of Cézanne, Lautrec, Signac, Bonnard, Vuillard, Degas and probably Van Gogh. His appetite for the new painters was insatiable. He painted *Le Moulin de la Galette* and *Cancan*, which betray no evidence of an instant metamorphosis; rather, it was as if he was clinging to what he knew in order to ward off exterior influences. With each new visual encounter he would react in the same way. It was necessary for him to assimilate the sense of disjunction created by such encounters so that he could integrate these new elements into his own method of working. Picasso spent Christmas of that year with his family and his friend Casagemas in Málaga. It was here that he realized that a barrier had formed between the conformist respectability of his family and his own ideas on how to run his life. He was 19 years old. Somewhere between Paris and Málaga, a moral

transformation had taken place, a definitive break with the life-style of those around him.

In January 1901 Picasso was in Madrid. Society women and courtesans with their sumptuous clothes and well-worn faces, vied for his attention as subjects. This is the period of *Woman In Blue* and the awesome *Woman With Jewels*. He had certainly been influenced by the suicide of his friend Casagemas. Death is not represented, but misogyny is evident. The great emotional moments in Picasso's life always appear in his painting, not in a way that is immediately obvious, but rather as a serious underlying message or, on the contrary, as the bursting forth of spontaneous joy.

Paris beckoned Picasso once more. The young Catalan dealer, Mañach, had organized an exhibition at the Ambroise Vollard gallery. After spending the month of April in Barcelona, Picasso moved back to Paris and set up home in the building shared by many Spaniards in the boulevard de Clichy in Montmartre. The exhibition was a success. His lively, colourful style pleased everyone. 'Every subject enraptures him, and everything, for him, is a subject, the frantic rushing of the flowers towards the light outside the vase, the vase itself, the table which supports the vase, and the luminous air which dances around it,' wrote the critic Félicien Fagus. The exhibition led to Picasso's first meeting with Max Jacob. Picasso was immediately captivated by his insight, his autonomy of judgement and his fiery spirit. A great friendship soon developed between them. Max Jacob welcomed Picasso and his band of young Spanish painters. The young poet read them his own verse and poetry by Rimbaud, Verlaine and Baudelaire. At night, the group of friends would visit the cabarets of Montmartre, Le Chat Noir and, when they could get tickets, Le Moulin Rouge.

Success encouraged the young painter to pursue his own course. It would have been easy to exploit the style so

well received by the Parisian public, but this was of no interest to Picasso. He changed his style and returned to large-scale composition. Beginning in August, he dealt with the death of Casagemas, firstly in *Death*, then in *The Burial Of Casagemas*. While there are clear references to

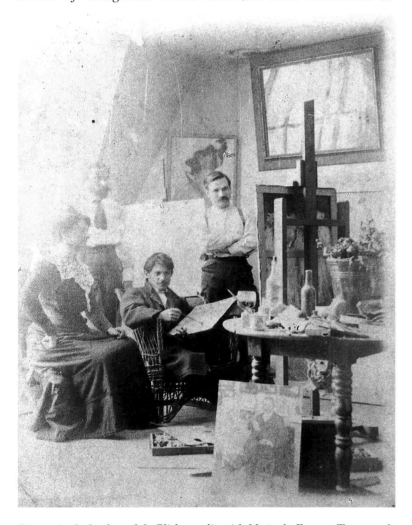

Picasso in the boulevard de Clichy studio with Mañach, Fuentes Torres and his wife, 1901.

classical burial scenes, this last painting belongs to a world which is intimately Picasso's. We should beware of appearances: the parody of El Greco's *The Burial Of*

Count Orgaz and the sacrilege implied. At this time of rupture from his family, the young Picasso was posing questions about the meaning of life. As the critic Roland Penrose remarked, this painting 'marks the final adolescent crisis and the painter's triumph over family influences'.

MONOCHROME

Having returned to Barcelona, Picasso worked on perfecting the style which had emerged in Paris, the blue universe, taking it to the extent of pure monochrome. The subjects he chose were the abject prostitute, the mother in misery, stooping figures. Mañach organized another exhibition, this time at the Berthe Weill gallery. Picasso, back in Paris for the occasion, showed four, or perhaps five, of his blue canvases. Charles Morice, the *Mercure de France* critic, was struck by 'the sterile sadness which weighs on all this young man's work . . . but there is a force, a gift, a talent'.

During the winter of 1902–3, Picasso and Jacob were in dire financial straits. They shared a room and a single bed on the boulevard Voltaire. Max was working in a shop, so Picasso could sleep in the daytime. At night, it was Max's turn to sleep while Picasso painted. Their good fortune had its limits, however. By the end of the year, all Parisian *joie de vivre* had disappeared. Jacob was out of work and Picasso was not selling. Once again, the painter returned to Barcelona where he wrote: 'My dear Max, I think about the room on the boulevard Voltaire, about the omelettes, the beans, the Brie and the fried potatoes. But I also think about the days of misery, and it's quite sad.' In fact, Picasso was never entirely at home in the role of the struggling artist. This time his stay in Barcelona was marked by the creation, in the spring of

1903, of a major work, *La Vie*, in which we see the last appearance of Casagemas. All the preoccupations of the blue period are united in this canvas. Picasso, at the age of 22, had experienced the pain of the world at large.

Between 1900 and 1904, Picasso was constantly on the move. During these four years, he crossed the Pyrenees eight times. In April 1904, he made up his mind. It had to be Paris. He installed himself in the Bateau-Lavoir, an

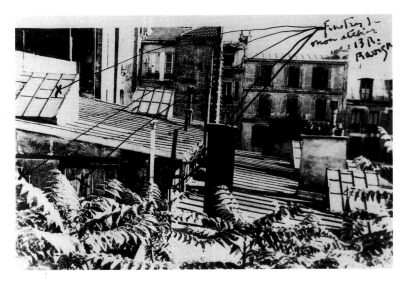

The Bateau-Lavoir, 'My studio window', 1904.

odd, dilapidated building which had become the bohemian centre of Paris. Picasso was to remain in his blue world for some months longer. As Gertrude Stein wrote, 'Staying longer in France this time, he was seduced by French gaiety, he painted in pink and called this his Pink Period.' At the end of 1904, the elegant, outlined figure of *The Actor* ushered in the pink period. 'In actual fact', Stein continues, 'there was also some blue in this period, but the characteristics were pink rather than blue.' The reason for this French gaiety went by the name of Fernande. In a pink-toned water-colour, contemporary with *The Actor*, Picasso is seen dressed in blue contem-

plating a beautiful sleeping woman, Fernande Olivier. They were both 22 years old. She very soon moved in with him and Picasso, wildly in love, painted her a thousand times. All the women he loved were to haunt his work in this way. One day they might pervade the whole canvas, while on another their presence is reduced to a symbol. The artist observes them, notes their particularities, is conscious of their moods.

The studio in the Bateau-Lavoir reeked of linseed and paraffin, with dozens of canvases heaped against the wall. 'A spring-mattress in one corner. A rusty cast-iron stove supporting a yellow earthenware basin . . . A straw chair, easels of all sizes, tubes of colour scattered over the floor, spirit containers, and a bowl for the *aqua fortis* . . . ' The disarray described here by Fernande Olivier seems always to have been necessary to Picasso. 'I found pots of colour, brushes thrown directly onto the parquet, squeezed-out tubes, bent and strangled in convulsive movement, imprinted with Picasso's feverish fingers . . . ' observed Brassaï, later. 'Mindless of inconvenience, he worked away from his easel, bent double, sometimes sitting on the floor, his canvas set up in any old fashion, any old where . . . '

NEW FRIENDS

Harlequin made his first appearance at the beginning of the blue period, taking his place amongst blind beggars and prostitutes. He was to return repeatedly throughout Picasso's life's work, sometimes melancholy, sometimes gay, mocking or dramatic. He could represent pain, tenderness or derision. In 1905, Harlequin found himself in the company of the *saltimbanques*, whom Rainer Maria Rilke described as 'these wanderers, men even more fugitive than ourselves'. Picasso used to go to the Medra-

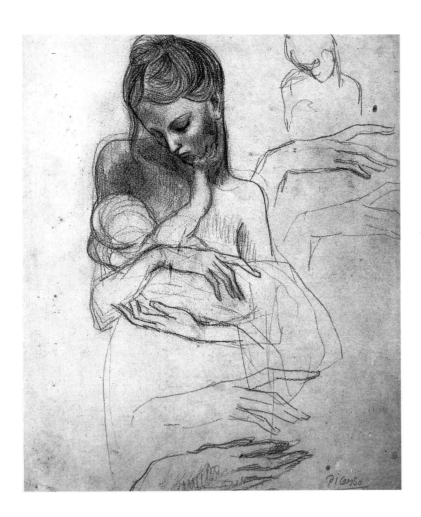

Mother and Child, *1904.*

no Circus. 'I was completely enamoured of the circus,' he confessed to Brassaï. 'I sometimes went several times in one week . . . Above all I loved the clowns. Sometimes we would stay backstage and chat with them at the bar for the whole evening. And did you know that it was at Medrano that clowns first threw out their classical costumes and began to dress in a burlesque manner? It was quite a revolution . . . They were able to invent costumes, characters, give themselves over to pure fantasy . . . ' Whether by a twist of fate or as a sign of destiny, Picasso's first

dealer, Clovis Sagot, was a former clown. 'He was a very, very hard man, Clovis Sagot, virtually a money-lender. But sometimes, when I was broke, I would stuff a few canvases under my arm and go and sell them to him . . . This, by the way, is how Gertrude Stein's brother came to see one of my paintings – at his place . . . '. 'We were all badly off. The most extraordinary thing is that, none the less, we managed to live', wrote Max Jacob. Cheap restaurants were plentiful in the narrow streets around the Butte de Montmartre. A little café which had recently opened, *Le Lapin Agile*, soon became a meeting place for

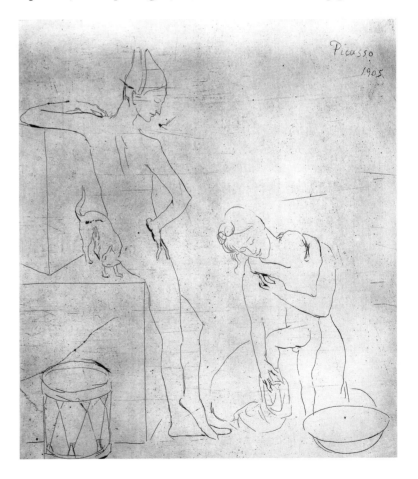

Le Bain, *1905.*

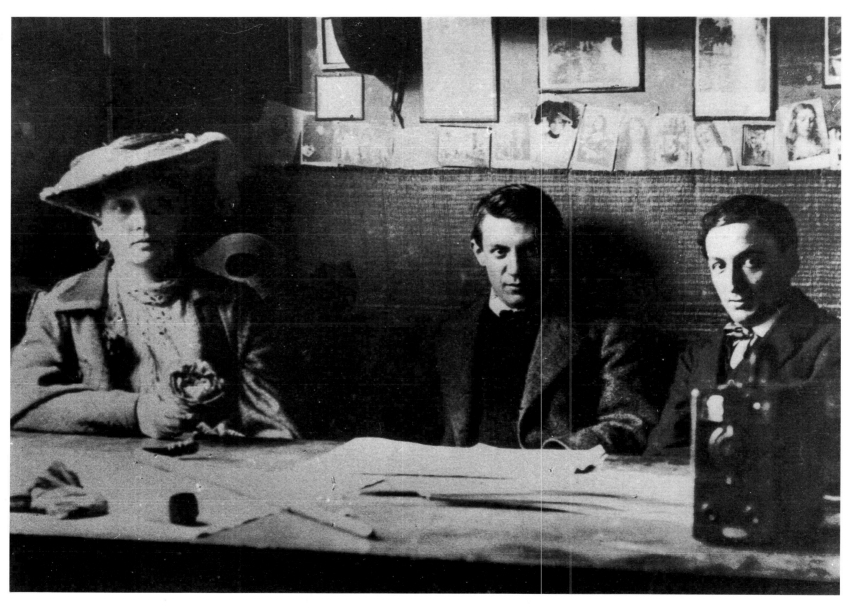

*Fernande Olivier, Picasso and Ramon Reventos in the studio of J. Vidal i
Ventosa in Barcelona, 1906.*

the group of artists and poets to which Picasso belonged. They would gather there of an evening to exchange ideas and to listen to Harry Baur and Dullin recite Ronsard or Villon, or to Francis Carco singing music-hall songs. Among the artists' works hung on the walls were paintings by Utrillo and Suzanne Valadon, and *Le Lapin Agile* by Picasso, accepted by the owner, Frédé, in lieu of payment.

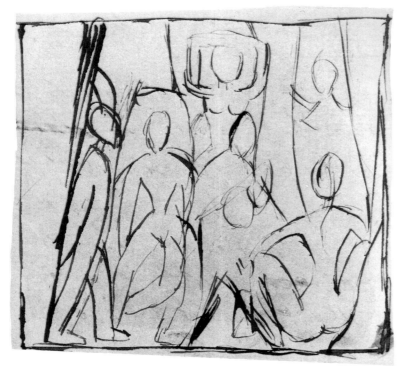

Study for Les Demoiselles d'Avignon, *1907.*

Picasso's studio was frequented by such men as Alfred Jarry, Charles Vildrac, Pierre MacOrlan, Guillaume Apollinaire and Max Jacob. Before long they were joined by art-lovers with the necessary purchasing power. Amongst these were two Americans, Leo and Gertrude Stein. On their first visit, they were so impressed that they bought paintings to the value of 800 francs. In 1906, the dealer Ambroise Vollard bought most of the paintings from the Pink Period, for the sum of 2,000 gold francs. Picasso and Fernande were thus able to afford a trip abroad.

Their first stop was Barcelona. Picasso introduced Fernande to his family and quickly headed for Gosol, a village close to the frontier with Andorra, accessible only by mule. This summer trip of 1906 was extremely influential in his development. He renewed contact with Roman art and Catalan gothic, and his passion for El Greco was revived. But most important of all was his discovery of pre-Roman Iberian sculpture. Its influence can be seen in the sculptural, clearly defined lines of his portrait of Gertrude Stein and in most of the nudes of this period. In fact, Picasso had ceased to think in terms of 'subjects'; he had begun to develop a pictorial space based on the effective relationships between bodies and objects, the very basis of Cubism.

CUBISM

In July 1907, after hundreds of drawings and preparatory studies, Picasso completed a huge canvas he had begun several months before: *Les Demoiselles d'Avignon*. The studio had been strictly out of bounds during these long months of work. When he finally allowed his friends to see the painting, reactions varied from stupefaction to complete incomprehension. 'It was the hideousness of the faces which scared the wits out of the semi-converted,' André Salmon observed. The great canvas remained with its back to the studio wall until 1916, when it was to receive its title. Bought by the collector Jacques Doucet, *Les Demoiselles* was not reproduced in France until 1925, and not publicly seen until 1937.

Whether or not Negro art had influenced Picasso in this painting is still open to question. Certainly, he

Study for Les Demoiselles d'Avignon, *1907.*

discovered this form of art at the Trocadéro museum in 1907, probably just after *Les Demoiselles*, and was deeply impressed. The art of black Africa persuaded him of the need to look at form from a new angle, a lesson he had already begun to learn from his observations of Iberian sculpture. But the most important influence on him at this period was Cézanne. A Cézanne retrospective in the Autumn Salon of 1907 and an exhibition of seventy water-colours at the Bernheim-Jeune brought him firmly back into Picasso's mind. Later, Picasso said to Brassaï: 'He was my one and only master ... I spent years studying his paintings ... Cézanne! He was like a father to us all. He's the one who protected us ... ' Braque shared Picasso's admiration for Cézanne, and from then on the two painters worked in close association.

In the autumn of 1908, Braque presented six new canvases, small landscapes, to the Autumn Salon. The jury was completely baffled by this new trend. Colour was no longer the principal element. The accent was on simple geometric forms. Matisse who was a member of the jury remarked upon 'these little cubes'. Two paintings were rejected and Braque immediately withdrew the others. Kahnweiler, who alone had embraced *Les Demoiselles d'Avignon*, decided to exhibit Braque in his gallery. This was the first Cubist exhibition.

Picasso worked relentlessly, even though, as Gertrude Stein noted, 'the result is disconcerting both for himself and for others. But what can we do? A true creator, an innovator can only keep on going forward, that's all.' Two years after *Les Demoiselles*, he felt the need to re-examine

Study for Les Demoiselles d'Avignon, *1907.*

his creative purpose to rediscover himself. He chose to go back to Horta de San Juan, his friend Pallarès' village. 'The competition with Cézanne', remarks Pierre Daix, 'really began during this stay in Horta and we can see the Santa Barbara mountain as another Sainte-Victoire . . . The connection is obvious, but it is also clear that Picasso had gone further. He captured his predecessor's grandeur by taking up his analyses and pushing them beyond the brink of traditional ways of seeing.'

This summer of 1909 marked the true beginnings of Cubism. Experimentation with the real remained at the core of Cubist ideas. Initially, objects and people were predominant. Their forms, instead of being literally reproduced, were analysed, but, little by little, the analysis itself gained the upper hand. In the last phase of Cubism,

Study for Les Demoiselles d'Avignon, *1907.*

in 1912 to 1913, Braque and Picasso were heading towards a synthesis of all data engendered by the analysis of forms.

On Picasso's return from Horta, Ambroise Vollard organized an exhibition of his latest works. Despite the hostility of the public at large towards the new Cubist movement, art-lovers were buying. Picasso and Fernande moved into a large, well-lit studio on the boulevard de Clichy. They had a maid to serve dinner, mahogany furniture, a grand piano, and, of course, paintings, more and more paintings by Matisse and Rousseau. Picasso had not joined the middle-classes – he did not do so even when he moved into the Vauvenargues château. It was simply that he could afford to surround himself with the things he liked. As a couple, Fernande and Pablo reacted

Study for Les Demoiselles d'Avignon, *1907.*

badly to the change in social status. A new woman came into Picasso's life – Marcelle Humbert. He called her Eva as if she was his first and only passion. He also called her *Ma Jolie* and he loved her; he said so and he wrote as

Man with Pipe, *1914.*

much to his friends and expressed his love in his paintings.

With this new woman came a new burst of creativity. During the summer of 1912, Braque had done a series of charcoal drawings in which he used coloured paper cut-outs. With this discovery, the two painters understood that their art would have to include elements from outside that were independent of painter and painting. It was the beginning of the road which was to lead to collage. To the detractors of this new tecnique, Picasso replied: 'paper lasts just as long as paint, and if everything ages at the same rate, why not? . . . In the future no-one will see the canvas. They will see the legend, the legend that the canvas has created; so what does it matter if the canvas lasts or not? They will do restorations, but a canvas only exists by virtue of its legend; the glued paper might just as well be part of the legend.' These observations made to Gertrude Stein are a way of divorcing himself from the judgement of others. Picasso always had to struggle to impose his ideas. Sometimes his remarks are disarming: 'they say that I can draw better than Raphael and probably they're right; perhaps I draw better. But if I draw as well as Raphael, I think that I have at least the right to choose my own path and they should recognize that right. But no, they do not want to, they say: no.' And then: 'there are so few people who understand, and when everyone admires you there are still so few who understand . . . Almost as few as before.'

The summer of 1914 found Picasso and Eva in Avignon. Braque was also there with Derain. The atmosphere was heavy. Storm clouds loomed ominously and, in August, war was declared. Both his companions were called up and he accompanied them to the station. His work was not interrupted that much, but his palette changed. Whereas green dominated *Portrait of a Young Girl*, his colours had become more sombre in *Bottle of Maraschino* and *Still Life with Fruit and Newspaper*. In Paris, Picasso was insulted in the street because he was young and healthy. His close friends had all gone to war. The only one to stay behind was Max Jacob, who was in a

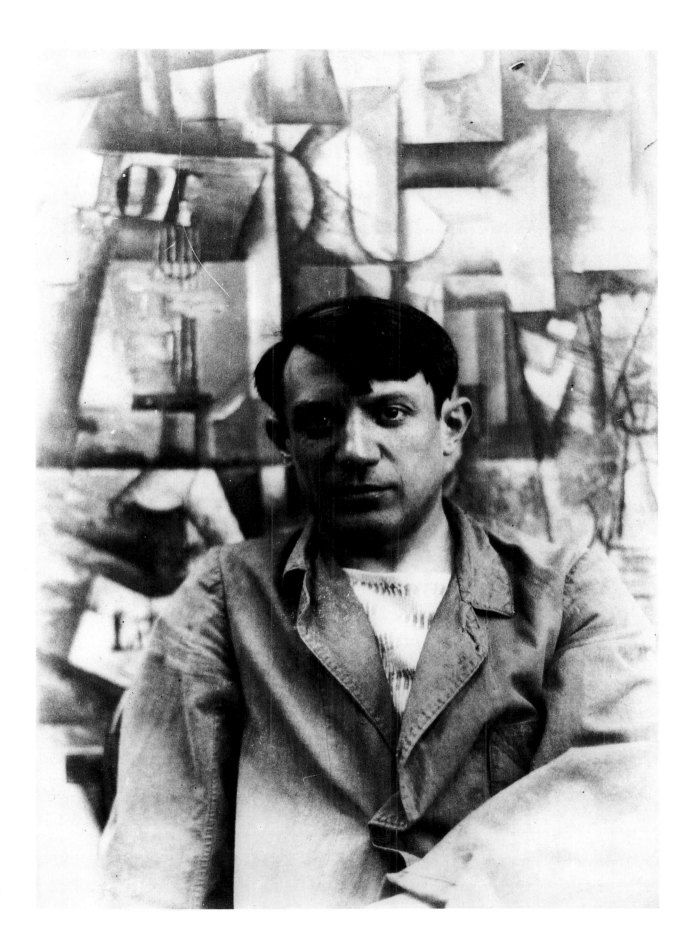

Picasso in front of the Aficionado-Sorgus, 1912.

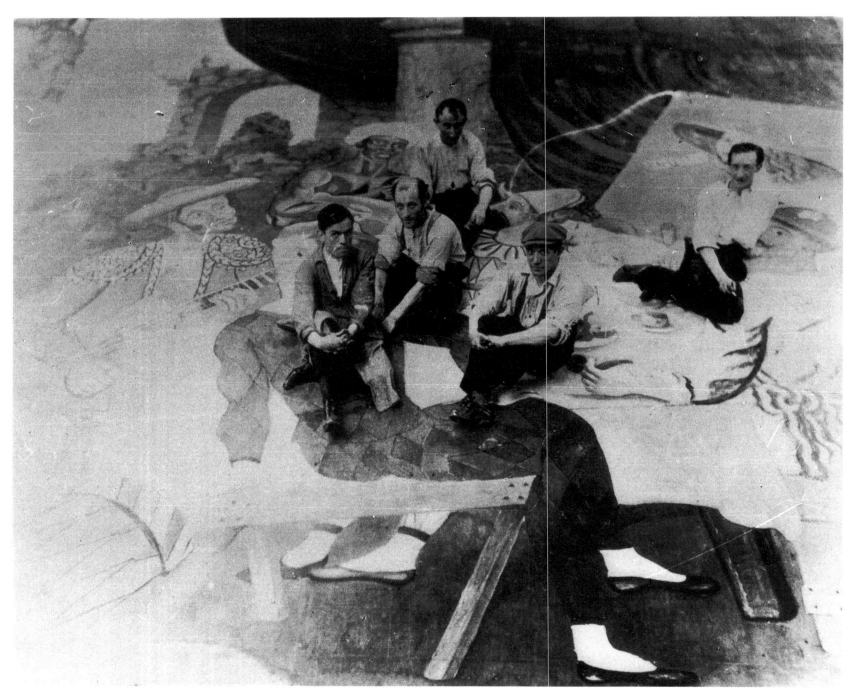

Picasso with the curtain openers from Parade, *Rome, 1917.*

delicate state of health. In the midst of these unhappy years, on 14th December 1915, Picasso suffered a personal tragedy. 'My poor Eva is dead,' he wrote to Gertrude Stein. 'It has caused me great grief, and I know that you must regret her passing. She has always been so good for me.' Once again, he did not express his loss directly in his painting, but the extreme stylization of the Harlequin of 1915 seems almost cruel against the intense black of the background: a cry from the heart in the face of this unjust and premature death.

Into this confusion and disarray there entered a fashionable young poet, Jean Cocteau, who wished to make Picasso's acquaintance. He later recalled his visit to the rue Schoelcher: 'I rushed up the stairs and my heart was pounding. I did not really like the negro statues, but rather, the use of their *bizarrerie* by the least bizarre of civilized men. On the floor were scattered odds and ends on which Picasso occasionally conferred the honour of use. Picasso was more interested in the objects which served his purpose than in beauty ultimately achieved.' Jean Cocteau had come in fact with a proposition: a ballet for Diaghilev, the prestigious head of the Russian Ballet, with a scenario by Cocteau, music by Satie, and décor and costumes by Picasso. It was to be called *Parade*.

THE RETURN TO ORDER

In February 1917 Picasso was in Rome putting the final touches to *Parade*. He had met Diaghilev in Paris and Stravinsky in Rome with Olga Koklova, a dancer with the Russian Ballet. At the end of April, the whole troupe came through Paris on its way to Madrid and Barcelona. Picasso followed. He was in love again, and Picasso in love was capable of anything! Olga was extremely beautiful. Picasso came back to Paris in October a new man; he

took care of his appearance, attended receptions given for the troupe, and became almost a society figure. He was 36 years old, with his whole life before him. He married Olga on 12th July 1918. She gave him a son, Paulo, on 4th February 1921. Between 1914 and 1917, Picasso became the complete master of his craft. His technical skill had reached perfection. Little by little, in his new works, we see the appearance of a style hitherto unfamiliar: draped figures, goddesses from antiquity in massive form, statuesque in their immobility. These were to appear as *Large Bathers*. Picasso's work, between 1920 and 1926, can be seen as a classical period, even though he completed Cubist paintings which were at least as important in number and quality as the realist works. Certain critics violently criticized his betrayal of 'modern painting'. To these, he replied: 'every time I had something to say, I said it in the manner in which I felt it should be said'.

In the course of the summer of 1922 in Dinard, 'the figures moved from monumentality to fullness but, at the same time, accidents were allowed to disturb the plastic, geometrical purity of the still lifes,' notes Pierre Daix. These still lifes, Cubist in nature, are remarkable for the light which pervades them, a lucidity filtered through extraordinary rays of colour. During these years of changing styles, the still life remained the theme to which Picasso consistently returned. It served to test his ideas and his technical innovations. The explosion of colours and grandeur of composition set the works of 1924–5 in a place apart from the rest of his work. *Studio with Plaster Head* is a synthesis of classical motifs. It also marks Picasso's first attempts to integrate Surrealist vocabulary.

By this time, Picasso had already finished *The Dance*, a work quite different from all the others, which reintroduced a sense of violence not seen since *Harlequin* in 1915. Hopes for a new post-war golden age had dis-

appeared, along with dreams of a life of contentment with Olga. She had become disenchanted; Picasso was bored with mundanities. The home they shared was a testimony to two separate beings, two separate lives. He organized the space into two apartments on separate floors. On the top floor was the studio. 'Madame Picasso never set foot in that apartment,' recalls Brassaï. 'Apart from a few friends, Picasso admitted no-one. The dust could fall and arrange itself at leisure, without fear of the maid's feather-duster. Below, a large dining-room with a round table in the middle, a sideboard, pedestal tables in each corner; a perfectly white salon; a bedroom with twin brass beds. Nothing out of place, not a speck of dust. Shining, lustrous parquet and furniture … Even his Cubist paintings, now classics, carefully framed and sharing the wall with Cézanne, Renoir and Corot, gave the impression of a rich dealer's house rather than Picasso's home … None of the special furniture he loved, none of the unusual objects which he liked to have around him … Olga took great care to see that Picasso did not impose his powerful personality onto a domain which she considered her own.'

FLIRTATION WITH SURREALISM

We know less about the period in Picasso's life which began with the tragic cry of *The Dance* than any other. His painting cries out to us that this was an unhappy time in which art aligned itself with a profound violence that nothing, for the moment, could resist. In 1926, he created a guitar from an old floorcloth, bits of string, nails and a strip of newspaper. He had, at one time, considered cementing razor blades into its frame so that anyone attempting to touch it would shred their fingers! The break from harmony and good taste was complete.

Picasso did not take refuge in Surrealism, but Surrealism provided the echo he needed. The Surrealists sought to plumb the depth of artistic creation, taking in the hallucinatory landscapes of the dream and the unconscious, a territory Picasso had already explored. Breton wrote in *Surrealism and Painting*, 'the mysterious route where fear lurks at every step, where the desire to turn back is only overcome by the vain hope that we are not alone, for fifteen years now, this route has been illuminated by a powerful beacon. For fifteen years, Picasso has been exploring this very route, his hands full of light, on a path where no-one before him even dared to tread.'

The liberties Picasso was prepared to take with the human body now knew no limit. The Cubist method had already led him, as early as 1913, to present a profile on a full-face portrait. By 1926, he had gone much further. Eyes, mouth, teeth, tongue, ears and nose are distributed here, there and everywhere with a single profile-line to represent the central division of the head. But, despite his extreme audacity, the model is still recognizable. The body underwent the same distortions. Bathers, a theme dear to the painter, are transformed into sculptural organic forms which have no counterpart in nature. Nevertheless, the way in which these massive creatures are represented on the beach is human and touching. Once again, Picasso is questioning the meaning of life. He reacted to his problems with Olga with new and powerful symbols. Irrational, psychological cruelty, an integral part of sexual relations, was put under the microscope by the Surrealists. Their research into the functioning of the unconscious included a passionate investigation of the myth and religious rites of primitive peoples. Here, Picasso found a reflection of his own questioning, intensified with the discovery of a new love, Marie-Thérèse Walter.

'When I met Picasso, I was seventeen. I was an

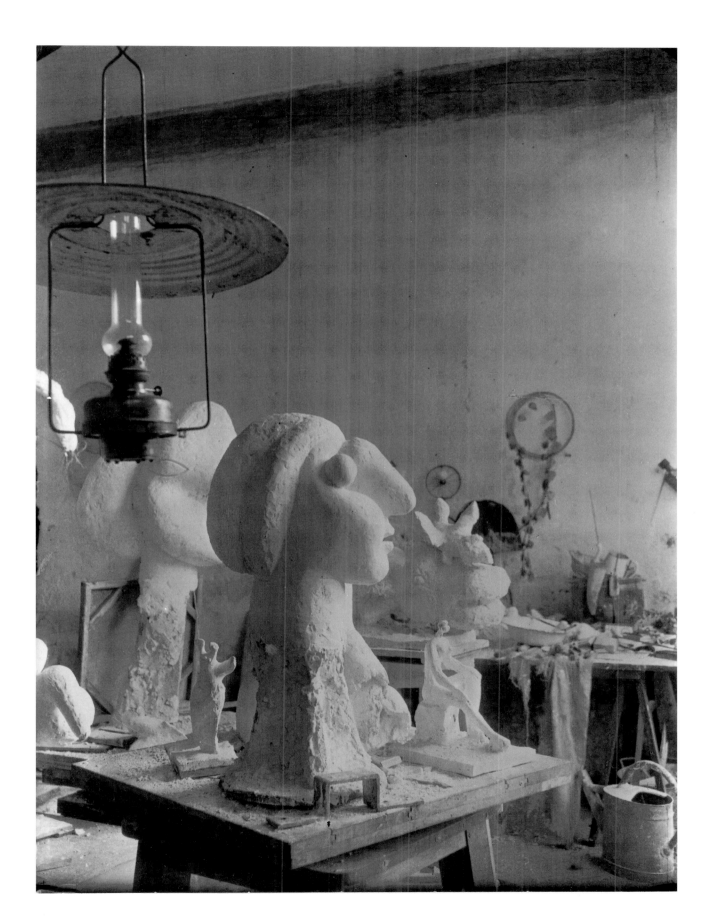

Plaster head in the Boisgeloup
studio, 1932.

innocent child. I knew nothing – about life, about Picasso. Nothing. I had been shopping in the Galeries Lafayette, and Picasso saw me coming out of the *métro*. He just took me by the arm and said: "I am Picasso! You and I are going to do great things together."' This was in February 1927. Marie-Thérèse did not appear officially until 1931. She gave birth to his daughter in 1935. It was on her account that he got divorced and, for her as much as of her, he painted the most astonishing portraits. As much as he loved, even worshipped her, she was to remain forever the woman in the shadows. At the beginning of her relationship with Picasso, Olga was still there. After the birth of Maïa, there would be Dora Maar.

This love-affair stimulated Picasso enormously. He was 46 years old. She was at the dawn of womanhood. He loved her blond hair, her luminous complexion and sculptural body. All this unleashed a tidal wave of sexuality which swamped his output, particularly in the series of sculptures, *Metamorphoses*. Brassaï comments that, with the arrival of Marie-Thérèse, 'all his painting began to undulate. As with flat surfaces and relief, straight angular lines interract with curves, soft giving way to hard, tenderness to violence. At no other moment in his life, was his painting so undulating, all sinuous curves, rolling arms and swirling hair . . . '

A NEW RÉGIME

'Do you know the *Crucifixion* by Mathias Grunewald, the central panel of the Isenheim altar?' Picasso asked Brassaï one day. 'I love this painting and I have been trying to interpret it . . . But as soon as I start to draw it, it becomes something else.' One can imagine Brassaï's surprise: 'only a few elements of the astonishing Calvary scene are still identifiable, a few allusions to the cross, to the body

convulsed in agony, to the protagonists in the drama. Picasso has completely transformed them. Mary Magdalen's mouth has become a kind of gaping funnel; the fingers of her clasped hands, a star-fish . . . Sometimes the construction is reduced to force-lines almost abstract from the composition, sometimes one might think that Picasso wanted to reconstruct the panel using crabs' pincers.' This was the first time a painting by an old

Sculptor at Rest III, *3rd April 1933.*

master had inspired his creative energies. 'Before Delacroix, Manet, Cranach, Poussin or Velázquez, Picasso chose Grunewald as his target. It was no longer a question of submitting himself to an influence as he had done in the past with Lautrec, Cézanne, El Greco and Ingres. By now, Picasso had become something of Lautrec, Cézanne, El Greco and Ingres. From now on, it was

to be the old masters who would inspire Picasso.'

Some time later, Picasso bought the Boisgeloup château 'no doubt to provide himself with a sculptor's studio,' remarks Pierre Daix, 'but also certainly to find a pretext for getting away from Paris (and Olga) and a haven for Marie-Thérèse'. Thus it was that sculpture, which had always occupied an important place in Picasso's output – his first sculptures date from the blue period

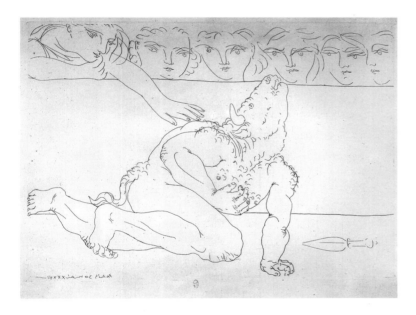

Death of the Minotaur, *30th May 1933.*

– now had a place of its own. At this time, Picasso renewed contact with his old friend, the sculptor Gonzalez, who was, amongst other things, an excellent metal worker. He quickly understood that sculpture was the central nervous system of Picasso's work.

With Gonzalez and the space available at Boisgeloup, sculpture in metal offered new possibilities to stimulate Picasso's exceptional creativity. The Cubist collages had shown that real objects could be combined to form a new

entity. Bits of iron, springs, saucepan-lids, nuts and bolts, carefully selected from the public tip, thus found themselves invested with a new life. However, Picasso insisted that they remained recognizable. Brassaï recalls the artist's anger on hearing that a publisher had not taken his *Bird* seriously – he made it from a child's scooter. 'An object! So my bird is only an object! Who does he think he is, this man? To tell me, Picasso, what is a sculpture and what is not a sculpture! He's got a nerve! Perhaps I know better than he does . . . What is sculpture? What is painting? They always cling to these antiquated ideas, these worn-out definitions, as if the role of the artist was not, precisely, to provide new ones . . . '

In a different style, Picasso began carving long, slender pieces of wood into human figures, later worked in bronze. But the most impressive sculptures of the Boisgeloup period are the large heads with protuberant eyes and noses, modelled in clay and plaster. They take their place in the monumental series *The Sculptor's Studio.* Between 20th March and 5th May 1933, Picasso engraved forty-two etchings on this theme. Drawn with a firm line in the neo-classical style, the bearded sculptor is completely engrossed in the work which dominates the space before him. At his side is the woman who inspired him. From this same period dates the famous series dedicated to the Minotaur. This powerful figure joins in the revelry of the sculptor and his lascivious companions. He takes part in their orgies as one of the invited guests but the Minotaur remains a beast. Two etchings from *The Sculptor's Studio* series show him dying in the arena. *The Blind Minotaur* is one of the most touching scenes. A little girl, clutching a dove to her chest, guides him without fear. In the two last etchings on this theme, her face is the face of Marie-Thérèse. An identification of Picasso as the Minotaur is likely. Half-man, half-beast, his powerful and sensual nature, his instinctive, spontaneous behaviour, his over-

bearing but likeable character do indeed correspond, in many ways, to the image Picasso had of himself. The finale takes place in the most important engraving of the period, *Minotauromachie*. The Minotaur's head is colossal, he is advancing on a female matador with naked breasts, lying across an eviscerated horse. The little girl who had been the blind Minotaur's guide is holding a bouquet of flowers and a candle which seems to fascinate the monster. Picasso's personal life was in disarray. His daughter, Maïa, had just been born and Olga had left, taking Paulo with her. The worst had happen to Picasso: he was obliged to think about things other than his art.

STERILITY

Since Olga, as Picasso's wife, was entitled to a half share in his possessions, the painter was now discovering the bitter truth of divorce. He had to share everything! Even if Olga affected disinterest, the lawyers had a field day. It was too much for Picasso, and he could not bring himself to paint. Sabartés recalls: 'he no longer went to his studio, the mere sight of his paintings would exasperate him, each one would remind him of something from the recent past, and each memory would sadden him. One day, absolutely convinced that he must change his routine, he set about washing nappies, for this at least had nothing to do with what had gone on before; apart from the novelty, he had the satisfaction of physical effort and the advantage of not having to see undesirable faces around him, while he took so much pleasure in living near Maïa.'

During this period, which he called 'the worst of my life', Picasso began writing poetry. To start with he would not show his notes to anyone but, little by little, the need to communicate overcame this reluctance and he began reading fragments to his closest friends. Obsessed by the idea of substituting one art form for another, of writing his paintings and painting his poems, he used drops of colour to represent certain objects, then began to write, punctuating his visual phrases with colours. He played with the images contained in words in the same way he had previously experimented with collages. He invented a completely personal system of punctuation. 'Punctuation', he said to Braque, 'is a G-string which hides the shameful areas of literature.' Words had become colours on the painter's brush: 'time that white in memory blue borders white in her eyes so blue and piece of indigo of silver sky white looks throught cobalt white paper that bluish ink her ultra-marine descends that white enjoys blue rest agitated in the dark green green wall her plesure writes rain pale green which swims green yellow . . . '. Breton was one of the first to acknowledge these poems. Several of them appeared in a special edition of *Cahiers d'Art*.

Gertrude Stein wrote: 'Picasso is too intelligent not to feel that writing with words, is, for him, not writing at all.' Without being quite so categorical, it does seem that, much as Picasso enjoyed writing, it was merely a palliative to the period of artistic sterility he was going through. As Stein also said: 'it is extraordinary how one can suddenly stop doing that for which one has been created, that which has taken up all one's life.'

It was at this point that Picasso began his long friendship with Paul Eluard. They had met shortly after the poet's return from the war but doubtless this was too early for their friendship to be cemented. Their closeness is recorded in a pencil portrait dated 8th January 1936. Six months later, it was used as the frontispiece to the first translation of Eluard's poems published in London. Picasso had just agreed to illustrate *La Barre d'Appui*, a book of poems by Eluard, published by Zervos. Roland Penrose describes their meeting in these terms: 'Eluard

was enchanted by this new intimacy with Picasso. He said at the time, and in all sincerity, that he was happy to live in this troubled century, above all because he had met Picasso. Reciprocally, Eluard's poetry, lyrical, passionate and rich in images, was the work Picasso admired the most in surrealist literature.'

GUERNICA

In July 1936, civil war broke out in Spain. Picasso was horrified. He immediately took up the republican cause against Franco's Fascist party. He heard from his mother in Barcelona that a convent a few yards away from the apartment she shared with her daughter and five children had been burned to the ground. The smell of smoke hung in the air for weeks. The defence of democratic freedoms had become a question of life and death for young Catalan poets, painters and architects. In Paris, and elsewhere in Europe, brigades were being formed to defend the cause of freedom alongside the Spanish republicans.

At the beginning of 1936, Paul Eluard had introduced Picasso to one of his friends, a serious young woman with dark, fiery eyes called Dora Maar. She was a painter and a photographer. Born of a Yugoslav father and a French mother, she had been brought up in Argentina and spoke Spanish. Picasso found in her a companion sympathetic both to his art and to the problems which currently preoccupied him. Dora first made her appearance in Picasso's painting in September of that year. From then on, Picasso was to divide his time between the blond Marie-Thérése and Dora, the brunette. They both inspired an equal number of portraits which alternated with Picasso's visits to Marie-Thérèse and Dora's visits to the artist's home.

At the beginning of 1937, Picasso began engraving two large plates divided into nine squares, each of which took the form of a post-card. His original idea had been to sell each engraving separately for the benefit of Spanish people in need. However, the effect of the whole was so successful that he decided not to divide it. It is prefaced by a long and violent poem by Picasso, published in Spanish, French and English and entitled *The Dream and Lie of Franco*. The violent atrocities committed by the head of the military uprising are depicted image by image. History proved Picasso to be a clairvoyant. On 26th April 1937, the Basque town of Guernica was bombarded. A shocked world discovered that this appetite for destruction knew no bounds.

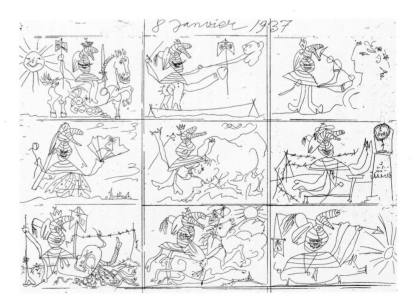

The Dream and Lie of Franco, *8th January 1937*.

In May, Picasso declared, 'the war in Spain is the battle between the forces of reaction against the people, and against freedom. All my life as an artist has been nothing other than a continuous struggle against reaction and the death of art. In the painting which I am working on and

which I shall call *Guernica*, and in all my recent works, I am frankly expressing my horror at the military cast which has sunk Spain in an ocean of grief and death.'

Guernica became a symbol. Its simplicity made it a universally comprehensible painting. In this canvas, Picasso rediscovered the frankness of expression that his artistic skill had obscured. One day, visiting an exhibition of children's paintings, he confessed to Roland Penrose, 'when I was their age, I could draw like Raphael. It has taken me a lifetime to learn how to draw like them.' True simplicity comes always at the end of a long voyage of discovery.

During the whole of 1937, Picasso used the faces of the women he loved to express his dispair and revulsion. In moments of repose, he would paint Maïa, either alone or with her mother. Even so, the image of the little girl with her toy boat and coronet of flowers could not overcome his distress. In this painting, her face seems to be melting in tears. In Europe, the political situation was worsening. In August 1939, Hitler invaded Poland and the French were mobilized. As in 1914, Picasso had to witness the departure of his friends. Arriving in Paris from Antibes, he found the city in panic under the threat of bombardment. He left immediately for Royan, taking with him Dora Maar, Sabartés and Kasbek the dog. Marie-Thérèse and Maïa were already there.

The day after his arrival, he began work. Painting was never a means of escape since he always expressed his doubts, his fears and disenchantments through his medium; but, nonetheless, painting gave him the strength to continue. A dearth of materials forced him to go back to Paris. He returned loaded with canvases and paint. One summer day in 1940, he watched the German army march into Royan. After the disastrous conclusion to the Spanish civil war, Picasso was now obliged to witness the defeat of his adopted country. With the signing of the armistice between Hitler and Pétain, he chose to move back to Paris. He installed himself in the rue de la Boétie, working each day in his studio in the rue des Grands Augustins.

Picasso chose to stay in Paris. He refused offers to leave the country in the same way as he refused the advantages which accrued to his position as a celebrated artist. 'A Spaniard never feels the cold', was his reply to an offer of coal. He decided to live out the Occupation, its privations and its risks. Picasso had a reputation as a revolutionary artist and was denounced as such. He was, however, never really disturbed by the Gestapo, despite his arrogance. One day, a Nazi officer seeing a photograph of *Guernica* on the table asked him, 'Did you do this?' Picasso replied 'No . . . you did.' He also distributed photos of *Guernica* amongst his German visitors, entreating them to 'take them. Souvenirs! Souvenirs!'

The autumn of 1940 was a period of readaptation. Despite the severe cold and the lack of heating, it was time to return to work. Women reclining and women seated alternated along with his portraits of Marie-Thérèse and of Dora Maar. But the atmosphere was still strained. He decided to invent a new way of working. 'On the 14th of January 1941', recalls Roland Penrose, 'on a long, bitterly cold evening, after a long day's work, he picked up an old note book and began to offer his friends an un-dreamed of surprise. Methodically, he started with a title, *Desire Caught by the Tail*, then came the frontispiece: a portrait in ink of the author from the view-point of a fly on the ceiling, the artist seated at his table, glasses on forehead and pen in hand.' One of the best examples of automatic writing was born.

A tragi-comedy in six acts, with characters called Gros-Pied, Angoisse Grasse or Oignon, Picasso's play is, essentially, about food. Its humour and invention are inexhaustible. Three years later, *Desire Caught by the Tail*

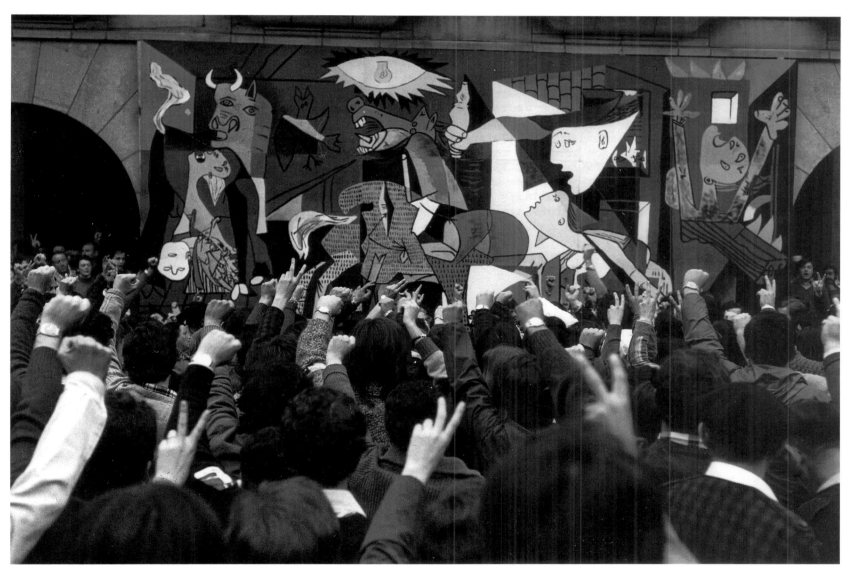

Guernica, *commemoration of the fortieth anniversary of the destruction of Guernica, 26th April 1977.*

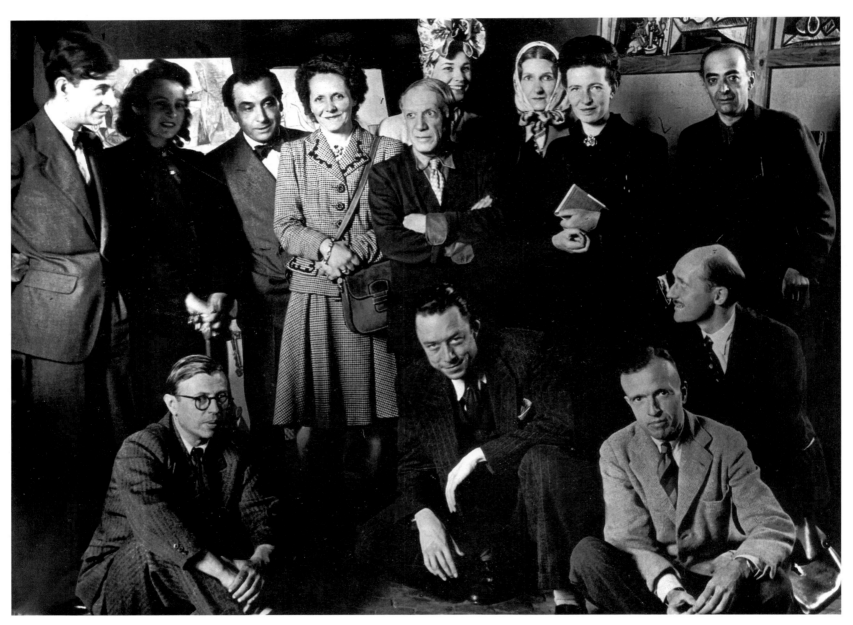

In Picasso's studio after the performance of Desire Caught by the Tail,
*1944. Top, from left to right: Jacques Lacan. Cécile Eluard, Pierre
Reverdy, Louise Leiris, Zanie de Campan, Valentine Hugo, Simone de
Beauvoir, Brassaï.* Bottom: *Jean-Paul Sartre, Albert Camus, Michel
Leiris and Jean Aubier.*

was performed under the direction of Albert Camus. The actors were all friends: Michel et Louise Leiris, Raymond Queneau, Jean-Paul Sartre, Simone de Beauvoir, Georges Hugnet, Jean Aubier, Jacques-Laurent Bost and Dora Maar. The performance took place in March 1944 in the Leiris home.

A NEW LIFE

The end of the war saw the end of Picasso's relationships with both Marie-Thérèse and Dora Maar. Enter Françoise Gilot, chasing away the storm clouds. Picasso met her in May 1943, but she did not really come into his life until November that same year. Françoise was demanding. She was a painter, and was to be his companion of hope after the Liberation, and his partner in commitment to Communism. Picasso's membership of the French Communist Party was publicly announced in October 1944. 'My membership of the Communist Party is a logical development from the rest of my life, from all my work. I am proud to say that I have never considered painting as an art-form of simple amusement or entertainment; using line and colour, since these were my weapons, I have always tried to penetrate deeper and deeper into an understanding of the world so that this understanding might liberate us more each day; I have tried to say, in my own way, what I considered to be the most true, the most correct and the best and, naturally, this has always been the most beautiful; the greatest artists know this perfectly well. Yes, I am conscious of having always struggled through my painting to be a true revolutionary . . .'

Picasso's membership of the Communist Party did not change his painting. He was looking for neither a new youthfulness nor a different source of inspiration. His painting was not allied to Communist ideology. Picasso did not change. He was a member of the Party and remained so until the end of his life, but he never became the painter *of* the Party even though he presented it with his famous dove of peace.

During the summer of 1945, Picasso began a new, large, dramatic canvas, *The Charnel House*. The horrors of war were just being revealed. Imagination had been completely outstripped by reality. 'In *The Charnel House*', notes Alfred Barr, 'there are no symbols, perhaps not even a prophecy. His figures are facts – the waxen, emaciated corpses of Buchenwald, Dachau and Belsen. The violent searing rage that made the agonies of *Guernica* tolerable is here reduced to silence. For the man, woman and child, this painting is a *pietà* without grieving, a burial without lamentation, a requiem without pomp'. Pierre Daix, who had been deported, observes: 'I could only see the extraordinary resemblance between these bodies and the heaps of corpses amongst which I lived the last days of the war. Only then did Picasso tell me that he had painted the canvas before pictures of the liberation of the camps had become available.' Picasso has often been reproached for leaving his canvas incomplete. 'What do they mean by finished, incomplete . . . Finished! Only death can finish anything.'

During 1945, Picasso and Françoise put each other to the test. Picasso left with Dora for Cap d'Antibes. Françoise went to Britanny. The young woman wanted to maintain her independence. Picasso finally made the break with Dora and Marie-Thérèse and, at the end of April 1946, Françoise moved in to Picasso's house. The result was a series of portraits, the most famous being *Flower Woman*, which used the pasted paper method. Françoise recalls: 'he painted a sheet of paper in sky-blue and cut it up into oval shapes corresponding, in different degrees, to the conception he had of my head: firstly, two

which were perfectly rounded, then three or four others, larger or smaller. When he had finished cutting them out, on each one he drew little signs for the eyes, nose and mouth. Then he pinned them to the canvas, one after the other, adjusting them slightly to the left or right, higher or lower. None of them seemed truly appropriate until the last was put in place. Having tried all the different possibilities, he knew exactly where he wanted it to be.'

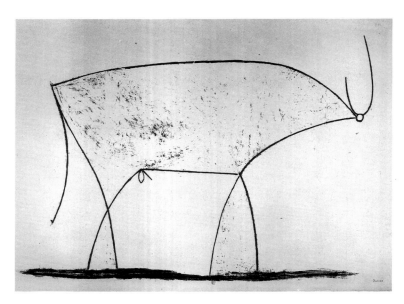

The Bull, *17th January 1946.*

According to Françoise, the sitting was a short one. She functioned simply as a departure point. The method of working she describes in detail did the rest. 'From time to time, he would walk to the other end of the studio and sit in the cane armchair which appears in a lot of his paintings. He would cross his legs, put one elbow on his knees and rest his chin on his first, studying his painting without a word sometimes for up to an hour. Afterwards, he usually went back to work on his canvas. Sometimes he would say: "I won't take this plastic idea any further today", and went to work on another canvas. He always

had several half-dry, incomplete canvases to choose from . . .'

In the first half of 1948, Picasso was almost exclusively occupied with lithographs. Fauns and centaurs, naked dancers, bulls and goats shared his creative universe with the two lovers. The owl made an impressive reappearance. It had been placed at the feet of the *Picador* – Picasso's first etching – but had not been seen since. It may be that the owl's return was connected with a trivial incident. Picasso had been brought a wounded owl which he nursed back to health. From then on, the bird, with its round head and piercing eyes, was to continually feature in his bestiary. It was clearly the return of *joie de vivre*, and this was the title of the great composition which marked the culmination of his stay in Antibes in 1946.

VALLAURIS

On 15th May 1947, Françoise Gilot bore Picasso a son. The new father was 65 years old. He delighted in this fresh manifestation of childhood. Two years later, Paloma arrived, the last of Picasso's four children. Some months after Claude's birth, Picasso moved to Vallauris. He had discovered this little town with Paul Eluard before the war and had returned there the previous year. This time, he struck up a friendship with the ceramicist Georges Ramié. Picasso became excited about the idea of moving into yet another means of expression, which would allow him to combine painting and sculpture. With extraordinary speed, he learned to measure the potential of working in clay and fired glazing. A valuable collaboration with Georges Ramié and his expert potters opened up a vast field of possibilities.

Row upon row of pitchers in the shape of doves, bulls, owls, birds of prey, heads of fauns and horned men

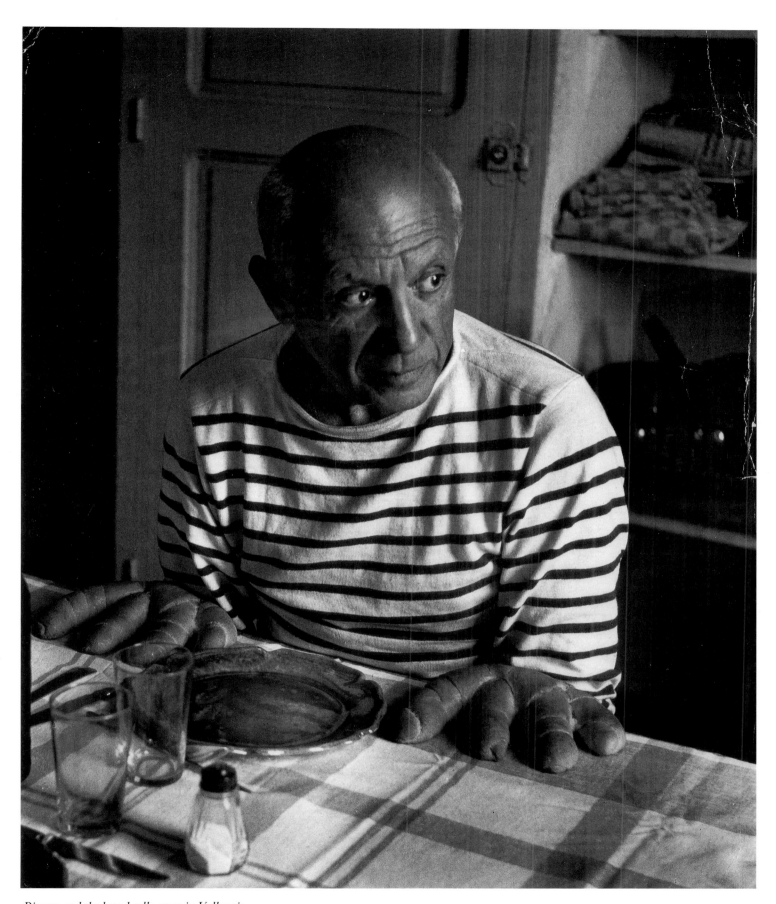

Picasso and the bread rolls, 1952 in Vallauris.

appeared on the shelves of Ramié's Madoura warehouse. Traditional provençal casseroles were decorated with bullfights and idyllic scenes. But, of all his inventions, those inspired by the female form are the most moving. A large number of pitchers and pots were transformed into representations of women.

The Picasso family had moved into an unprepossessing pink villa, 'La Galloise', perched on the terraces of the Vallauris hills. Picasso was completely absorbed in his new family. Numerous drawings and paintings show the children at play, dressed in brightly-coloured clothes. They are seen to be intrepid, resourceful and brimful of energy. As he had done with Paulo and then Maïa, Picasso took part in their games. He made dolls for them out of little pieces of wood decorated with simple lines in coloured chalk.

Throughout the summer, the family spent its mornings on the nearby beach of Golfe-Juan. Picasso taught Claude to swim. News of their presence spread quickly, and the Picassos were rarely alone at lunch in the restaurant on the beach. Picasso himself had become a symbol. In Vallauris, a bread roll in the form of four points like little stubby fingers was called a 'Picasso'. Discovering the existence of these curious loaves. Picasso used to amuse the assembled company by putting one of them up his sleeve as we see in the photograph by Robert Doisneau.

Their happiness at 'La Galloise' was short-lived. Françoise was young, ambitious and headstrong, and could not tolerate living in Picasso's shadow. At the end of the summer of 1953, she returned to Paris with the children, leaving him alone in Vallauris. Françoise has often been quoted as saying that she did not wish to spend the rest of her life with a historical monument. Picasso distracted himself from his worries by launching into a series of drawings which Michel Leiris entitled *Picasso and the*

Human Comedy. This was, in fact, an autobiography in pictures. The actor-clowns, acrobats and monkeys reappear, but these companions of his youth, like Picasso himself, have grown old. The theme of painter and model triumphantly returns. The love of beauty, youth and women is still there, but the painter is old. He is critically surveying his whole output. Nothing is spared, least of all the critics who have praised the smallest spot on his canvas. Bitterness and derision are present, but only as a form of exorcism. The themes of masks, old age, eroticism and the folly of the art world are yet to come.

CONVERSATION WITH ART

In 1952, Picasso met Jacqueline, a young divorcée and mother of a little girl. She first appeared in his painting in June 1954, before they had begun to share their lives together. Picasso organized all the available space in the painting as a function of her image.

The years from 1954 to 1963 were entirely devoted to paintings from the past. Picasso analysed, deconstructed and endlessly reconstructed masterpieces by other painters. Out of one canvas, he created a hundred, exhausting all the available possibilities, in an attempt to prove his own distinctive style, to test the power of his own painting on a given subject, beginning with *Women of Algiers* by Delacroix. Jacqueline, in a crouching position, exactly resembles the woman with the rose holding the houkah in Delacroix's painting. This seems to have been the catalyst which inspired him to continue these studies. Numerous preparatory drawings analyse women's postures, superimposing and overlapping them.

In May 1955, Picasso and Jacqueline left for the south of France where they bought a villa, 'La Californie', a large, turn-of-the-century building surrounded by a lux-

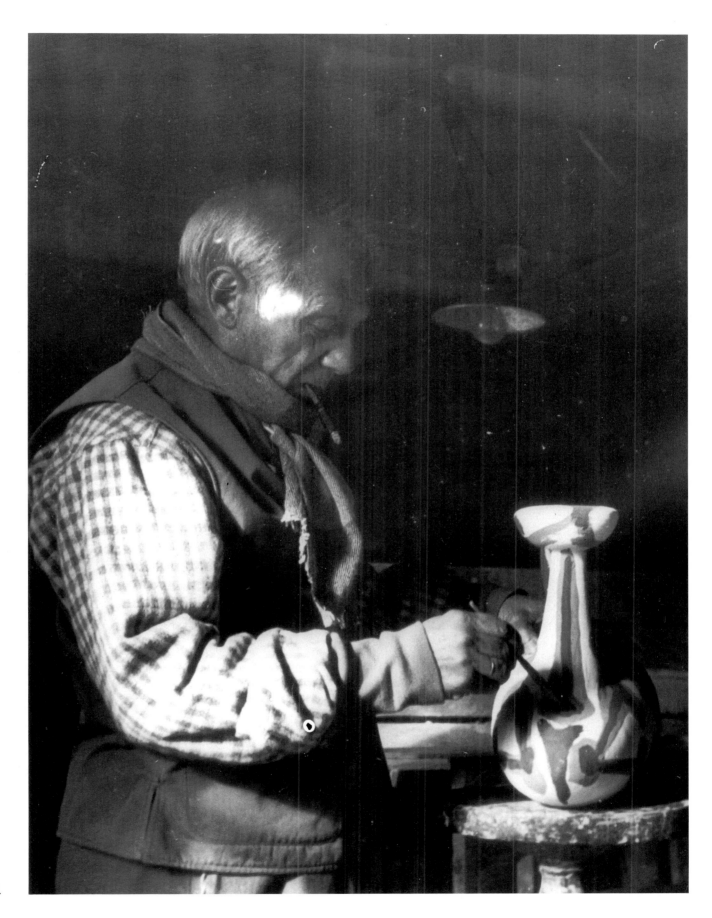

Picasso painting a pot, 1958.

uriant garden. Picasso immediately took over the ground-floor as his workplace, and incorporated it into his painting. The result was *Studios* or, as he called, them, 'interior landscapes'. In the same way that he had entered into a dialogue with Delacroix, this time he addressed himself to Matisse, still proving his own pictorial language.

Picasso pursued these conversations with Velázquez and *Las Meninas*, perhaps the most disturbing painting in the history of art, in a dialogue lasting over four months between August and December, 1957. 'Look at it', he told Roland Penrose, 'and try to discern where each of these characters is really situated in terms of the others. Velázquez is in the painting although, really, he shouldn't be; he's turning his back to the Infanta whom at first glance we take to be his model. He is facing a large canvas on which he seems to be working, but we only see the back of the painting, and we have no idea what his subject is. The only solution is that he is painting the king and queen whom we only see as reflections in the mirror right at the back of the room. So, Velázquez is not painting *Las Meninas*, and these maids of honour are gathered around the painter, not to pose, but to look at the portraits of the king and queen and like them, we are behind the ladies in waiting.'

In the first painting of 17th August, the figure of Velázquez is so large that he touches the ceiling, but soon Picasso began to concentrate on the Infanta who became the principal character. Alone or accompanied by her 'meninas', full length or simply as a bust, she is treated alternately in simplified forms, in flat surfaces or in agitated lines, thick and superimposed. *Las Meninas* was Picasso's first return to Spain. He went back to it later at Vauvenargues, and then again in Avignon.

When property developers threatened to build all around it, 'La Californie' ceased to be a haven of peace.

Besides, the whole world seemed to be lining up to catch a glimpse of the celebrity. Picasso was finding it increasingly difficult to live with his image as one of the monuments of the Côte d'Azur. In September 1958, he decided to buy the Vauvenargues château. 'I have bought Sainte-Victoire', he proudly announced to Kahnweiler. The latter, who had not seen any of Cézanne's paintings on the market, asked, 'Which one?' and Picasso triumphantly replied, 'The real one!'

And so Picasso moved into Vauvenargues with all his paintings and his collection of works by other artists: Le Nain, Matisse, Courbet, Renoir, Rousseau. He worked in the large salon, which was dominated by the bust of a former marquis of Vauvenargues on the mantelpiece. Jacqueline was the perfect 'Queen of Vauvenargues', as seen in her portrait, *Jacqueline de Vauvenargues*. They

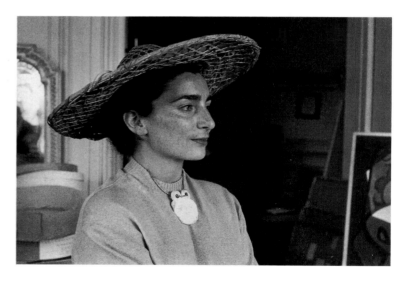

Jacqueline Picasso, 'La Californie' villa, 1957.

married, in the utmost secrecy, on 2nd March 1961, at the *mairie* in Vallauris. In June, Picasso and his new wife set up house at Mougins, in a typically provençal house called Notre-Dame-de-Vie. From the olive-groves and

*Jacqueline and Pablo Picasso
with Jean Cocteau at a bullfight,
1955.*

cypress terraces, they overlooked the Esterel mountain range and the fortified village of Mougins on the hillside.

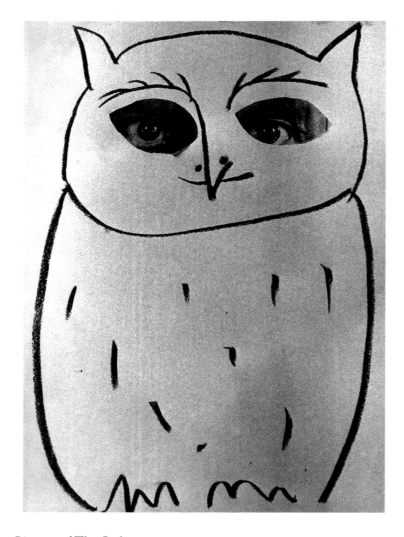

Picasso and The Owl, *1957.*

In August 1959, Picasso returned to his dialogue with major painters. This time, it was Manet's *Dejeuner sur l'herbe*. Picasso intermixed Manet's theme of the old musician with his own preoccupations: swimmers and children playing. For the next two years, Picasso's main point of reference was to be the *Déjeuner*, moving on, in 1962, to *The Rape of the Sabine Women* as interpreted by both Poussin and David, and Poussin's *Massacre of the Innocents*.

In 1963, Picasso returned to one of his favourite themes: the painter and his model. The painter is armed with his attributes, palette and brush, canvas on easel, seen in profile with his nude model, sitting or reclining. Clearly, these are not self-portraits. Picasso used neither easel nor palette. They were, rather, variations on a theme which dealt with his profession. Picasso, the man, thought of himself as sculptor, poet, man of the theatre, never simply as a painter. As he remarked on discovering the magnificent view from the apartment window at Royan: 'How wonderful this would be for someone who believed in himself as a painter!' Picasso was always Picasso, aware of himself as a larger than life indidivual endowed with exceptional powers of observation. In insisting on this theme, his imagination knew no bounds, pushing the relationship between painter and model to its ultimate realization. But was this simply imagination? Once he confessed to Pierre Daix that he really preferred to paint without a model 'because when you've got one you always wind up in bed!'

THE LATE PICASSO

Towards the end of his life Picasso's energy was limitless. Here, figures speak louder than words: 194 drawings between 15th December 1969 and 12th January 1971, 156 engravings between 1970 and March 1972, 172 other drawings between 21st November 1971 and 18th August 1972, 210 paintings between 25th September 1970 and 1st June 1972; to which we must add the 57 drawings donated to the Arles museum and others given to friends.

March 1951.

Picasso had, in fact, retained the speed of execution he displayed in his adolescence in Barcelona. Concentrated on the essential, and having acquired total freedom in terms of style and materials, he simplified things to the utmost. He used repetition as a creative force. Picasso had always preferred the idea of series, or variations to that of a single masterpiece, but now, by systematizing the process he created one work which was itself a collection of paintings on the same theme. Finally, more than ever, he was reaffirming the erotic dimension of life, in love as in art. The sexual violence of *Kisses* and *Embraces* reveals the importance in his life of physical passion. It has taken

anything else I've ever done . . . For the first time Picasso was staring death in the face. He even managed to paint it. Less than a year later, on 8th April 1973, he died at home, in Mougins.

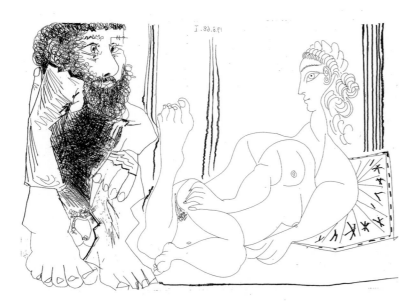

more than ten years to assimilate the late Picasso and to comprehend his eternal modernity.

On 30th June 1972, Picasso did his last self-portrait. His colours were blue-green, mauve and black. 'I did a sketch yesterday,' he told Pierre Daix, who was on a visit to Mougins, 'I think there's something in it . . . It's unlike

March 1951.

THE PLATES

Woman in Blue, 1901

133.5 × 101 cm, National Museum of Modern Art, Madrid

Picasso had discovered Paris, the Moulin de la Galette, the cancan. On returning to Spain, he chose Madrid in which to explore his individual style, distancing himself from current trends. *La Vie Parisienne* was still in his mind, however, and his artistic attention soon focused on society women and courtesans. Steinlein and Toulouse-Lautrec were never far away. There are traces of a misogyny and a cruel humour in this painting that are typical of the creator of *La Goulue*, with the added edge of a certain Spanish sang-froid. Picasso painted a remarkably powerful series of portraits of women, all testaments to his consummate skill as an artist. *Woman in Blue* featured in Madrid's first National Exhibition of Fine Arts in 1901 under the working title, *A Figure*. The rapid execution of brush-strokes in the background gives it a rhythmic quality; the sumptuousness of the dress, in a harmony of greys and blues becomes a pretext for the rich exploitation of pictorial matter. The decorative motif at the foot of the dress is in a direct line of descent from the traditional Spanish painting reminiscent of Velázquez, which was to be reiterated in late Picasso with the series *Las Meninas*.

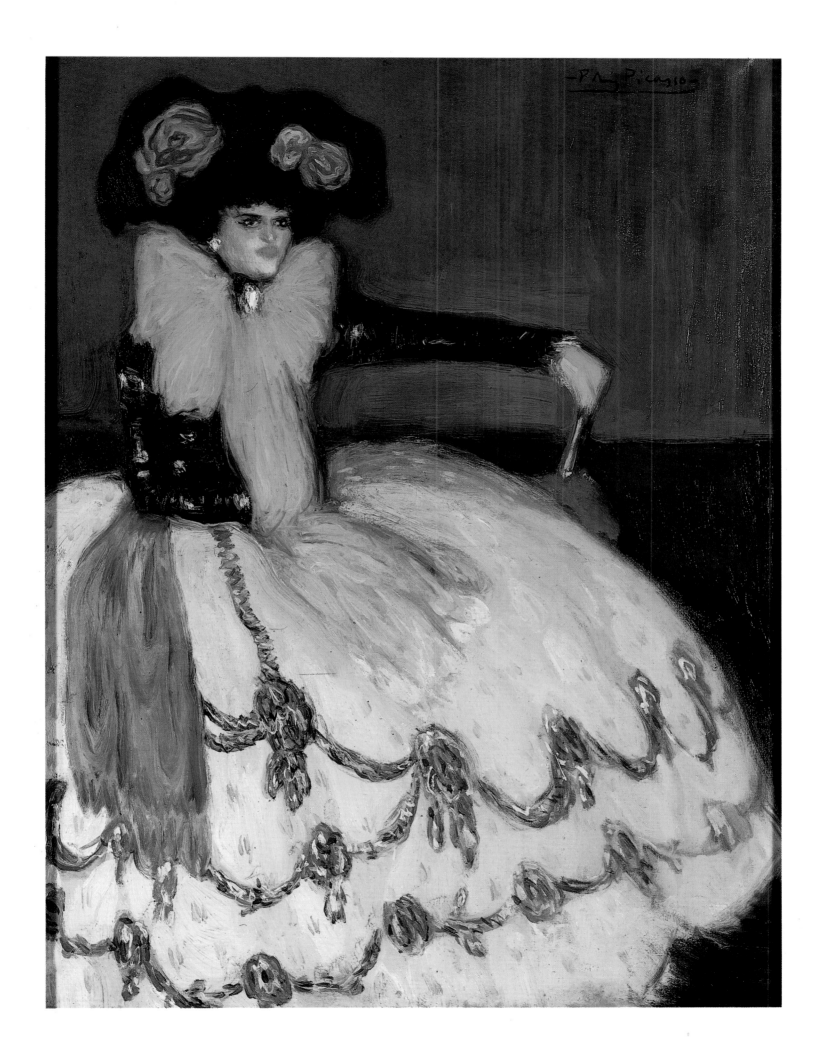

Harlequin, 1901

82.7 × 61.2 cm, Museum of Modern Art, New York

Harlequin made his first appearance at the beginning of the Blue Period. The sad and solitary acrobat took his place in a gallery of blind beggars and prostitutes. In this painting, Picasso has removed all sense of depth. The sophisticated balance of the whole is achieved by the contrast between straight lines and curves, between Harlequin's chequered costume and the exuberance of his ruff and the stylized floral motif. The gesture of his hand suggests a melancholy which signals the sentimentalist symbolism of the Blue Period. There are echoes too of the symbolist aesthetic of art nouveau.

The image of Harlequin recurs intermittently throughout Picasso's work. It may be that he represents the artist's own image of himself; in any event, Harlequin speaks the truth. Here Picasso is revealing the secret of his own increasing solitude. On the death of his companion Eva, he would allow Harlequin to express his grief; in *Paulo as Harlequin*, he exudes paternal affection.

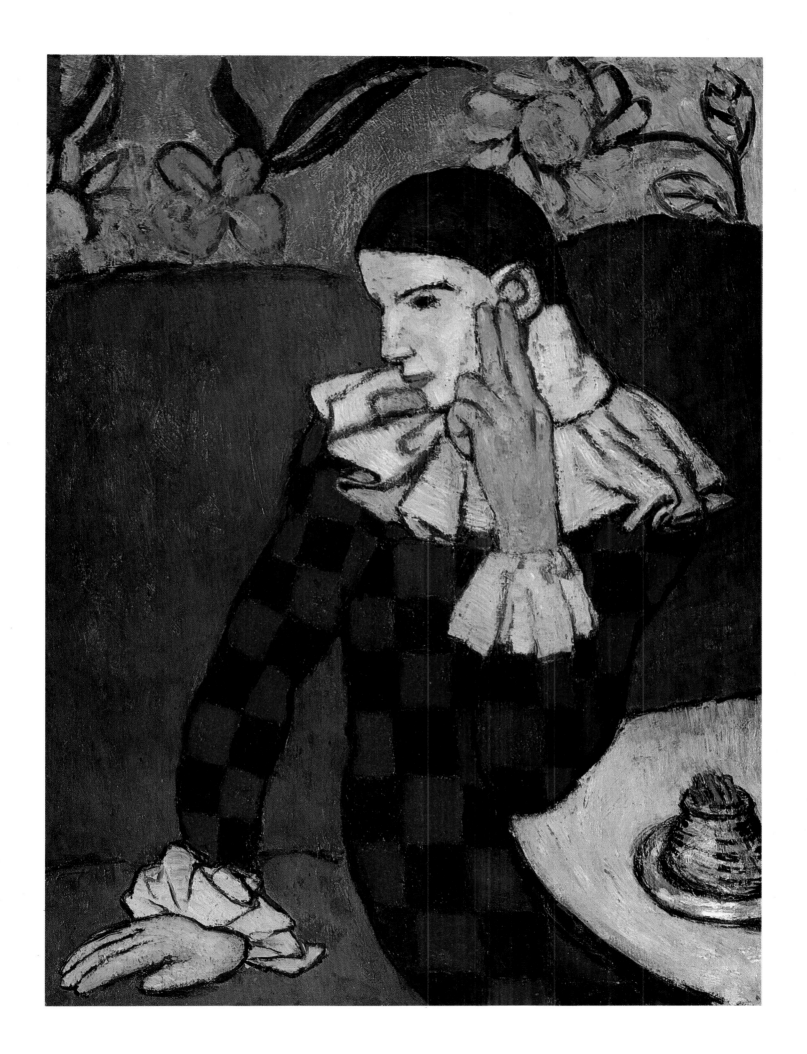

Self-Portrait, *1901*

81 × 60 cm, Picasso Museum, Paris

Picasso was only 20 years old but the image he presents of himself here ages him considerably. His hollow expression, pallid complexion and heavy beard and the turned-up collar of his greatcoat all contribute to a feeling of melancholy and solitude. The psychological intensity behind his lowering, almost hallucinatory gaze evokes certain Van Gogh portraits, whereas the powerful emotion achieved by the simplification of volumes and contours is closer to Gauguin. The choice of blue as his means of pictorial expression accentuates this feeling of hopelessness. His friend and biographer, Jaime Sabartés wrote: 'Picasso believed that suffering was the very basis of his being.'

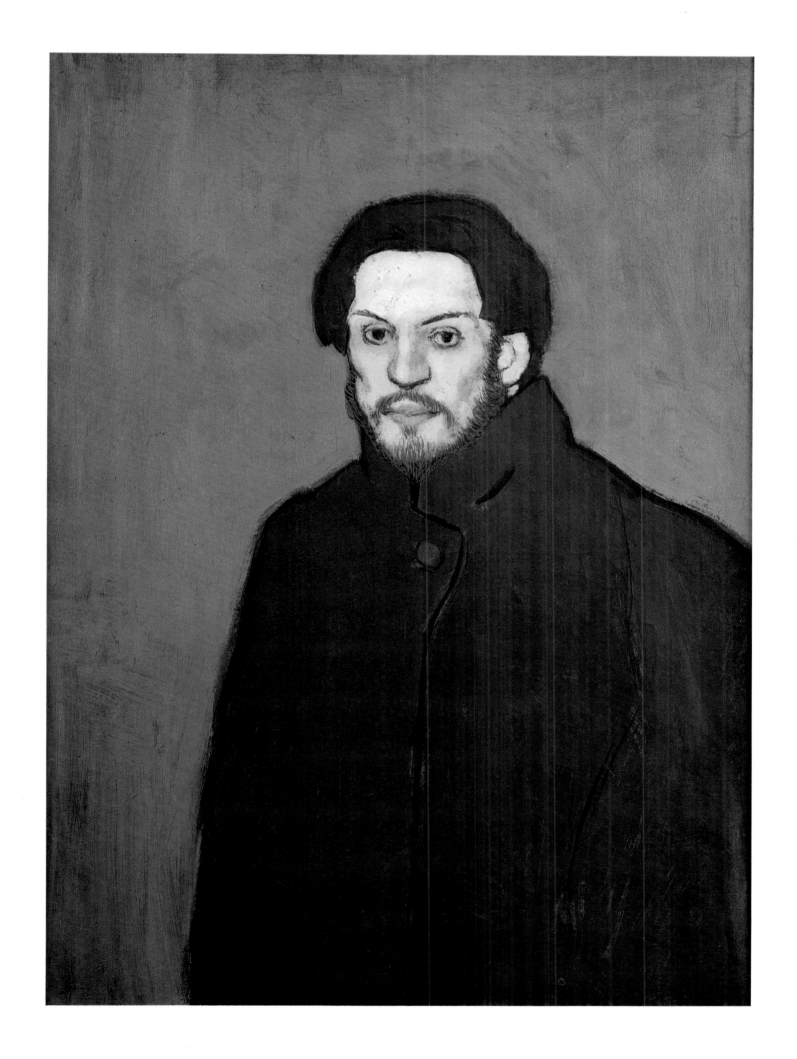

La Vie, 1903

196.5 × 128.5 cm, Cleveland Museum of Art

La Vie is a symbolic composition in which the atmosphere of the Blue Period and most of its themes are brought together. The meeting of two beings is a frequently recurring subject in early Picasso. His friend, the painter Carlos Casagemas, had killed himself, grieving for love. Certain early studies reveal that Picasso's original intention was not to represent Casagemas, but rather to evoke his memory in a large allegorical composition. In some of these sketches we even see the face of the artist himself.

La Vie, the largest painting from this period, is asking a question: namely, is happiness really possible? Picasso's reply tends towards the negative. Both the nude couple on one side and the emaciated mother on the other are denying the promise of love. Whichever road we take, despair would seem to be lurking around the corner. The man, that is to say Casagemas, extends his finger towards the woman and child in a gesture which recalls Michelangelo's *Creation of Man*. But there the finger of the creator is transmitting life to his creation. Here, Casagemas' finger, pointing into space, is a symbol of impotence, the real reason for his suicide. In between the man and the mother, two nude studies remind us of the existence of creation. One of them evokes the image of a desolate couple, recalling *The Embrace*. The other depicts a solitary woman prostrate in the same position as her counterparts: a symbol of solitude and abandonment. In fact, Picasso is asking the ultimate question: can art survive death? For the time being he offers no reply, but we know that throughout his life art would be, for him, both his escape and his salvation.

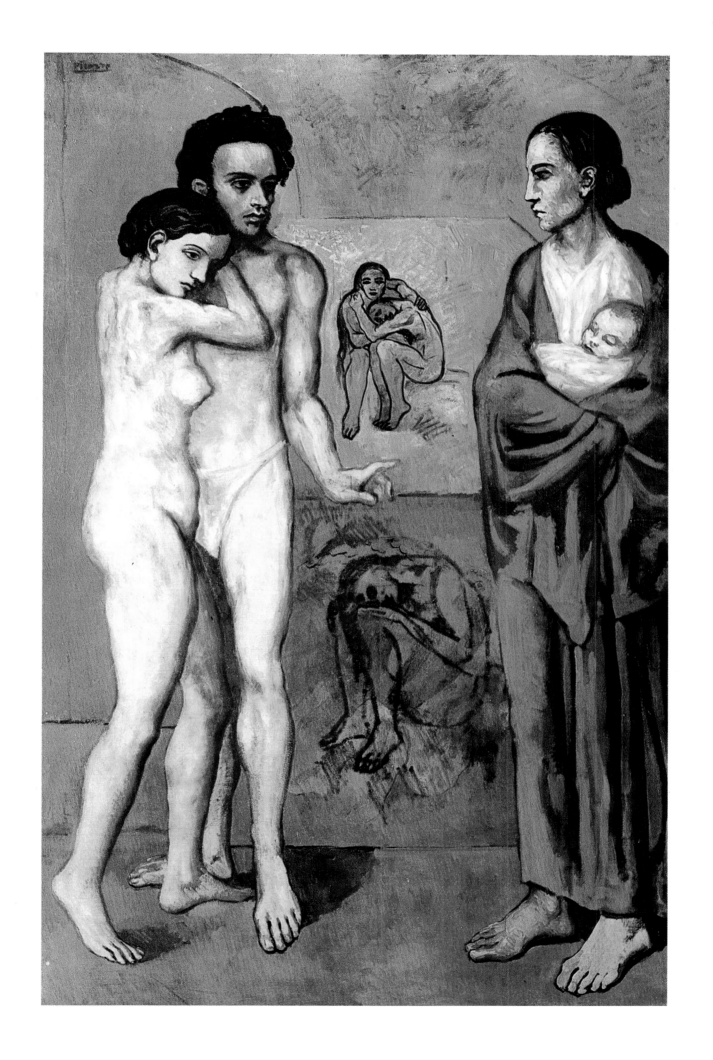

The Acrobat's Family with a Monkey, 1905

104 × 75 cm, Konstmuseum, Göteborg

The Acrobat's Family with a Monkey is one of the most important works that Picasso produced in his 'blue' to 'pink' transition period. At this time, the subject of domestic intimacy was prevalent in his painting, and the ambivalence of Picasso's feelings towards this 'theme' is most strikingly illustrated in this particular work. That it was the painter's own circumstances which partly inspired the study is unquestionable. He was now living with the beautiful Fernande Olivier, who had adopted a child and had soon become a constantly adoring and devoted 'mother', while Picasso found it impossible to sustain a consistently paternal role.

On studying the painting we can detect a certain awkwardness in the attitude of the acrobat, which suggests a distance in his relationship with the child similar to Picasso's detachment from his adopted daughter. The most notable feature must be the monkey, probably inspired by Picasso's pet monkey. This animal has always been, of course, a natural companion of fools, jesters and 'acrobats' since medieval times. It is interesting to note how alike the attitudes of man and monkey are in the painting and how the compositional relationship of both to the mother and child match each other.

What cannot be ignored is the obvious influence of the Renaissance painters in Picasso's work. We are reminded, vividly, of Raphael's *Holy Family with the Beardless St Joseph*, where there is the same elegance and serenity of the mother, the detached air of the 'foster' father and the lively movement of the child. In Picasso's compelling picture, however, there is not even the eye contact between father and child that is present in the Raphael.

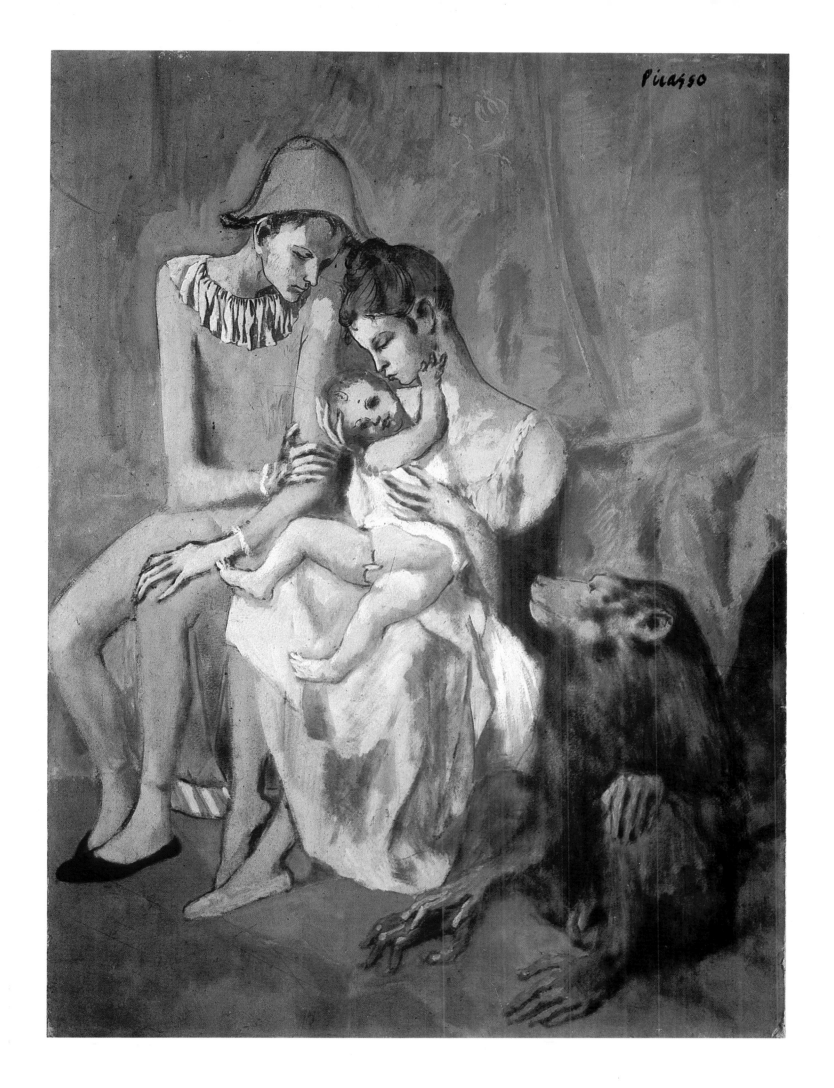

Portrait of Madame Canals, 1905

88 × 68 cm, Picasso Museum, Barcelona

Picasso had now been living for about a year with Fernande Olivier, a beautiful and shapely woman of whom he was both proud and jealous. She shared his bohemian life at the Bateau-Lavoir. Picasso sparkled amongst his artist friends. Amongst these was the Catalan painter, Ricardo Canals and his wife, 'the beautiful Roman woman, Benedetta, a former model for Degas and Bartholomé'. During the summer, Picasso spent some time in Holland. The country was not to his liking, but the Dutch girls managed to convert him to a more realistic conception of feminine beauty. On his return, Picasso transformed the beautiful Italian into a Spanish girl with a mantilla headdress decked with a mauve flower. There is something of Velázquez here, especially in the distant, lady-like air he gives to his friend's wife. The motif of the shawl, or mantilla, prefigures the portrait of *Olga with Mantilla*. The portrait of Madame Canals marks the beginning of a more classical period, dominated by formal balance.

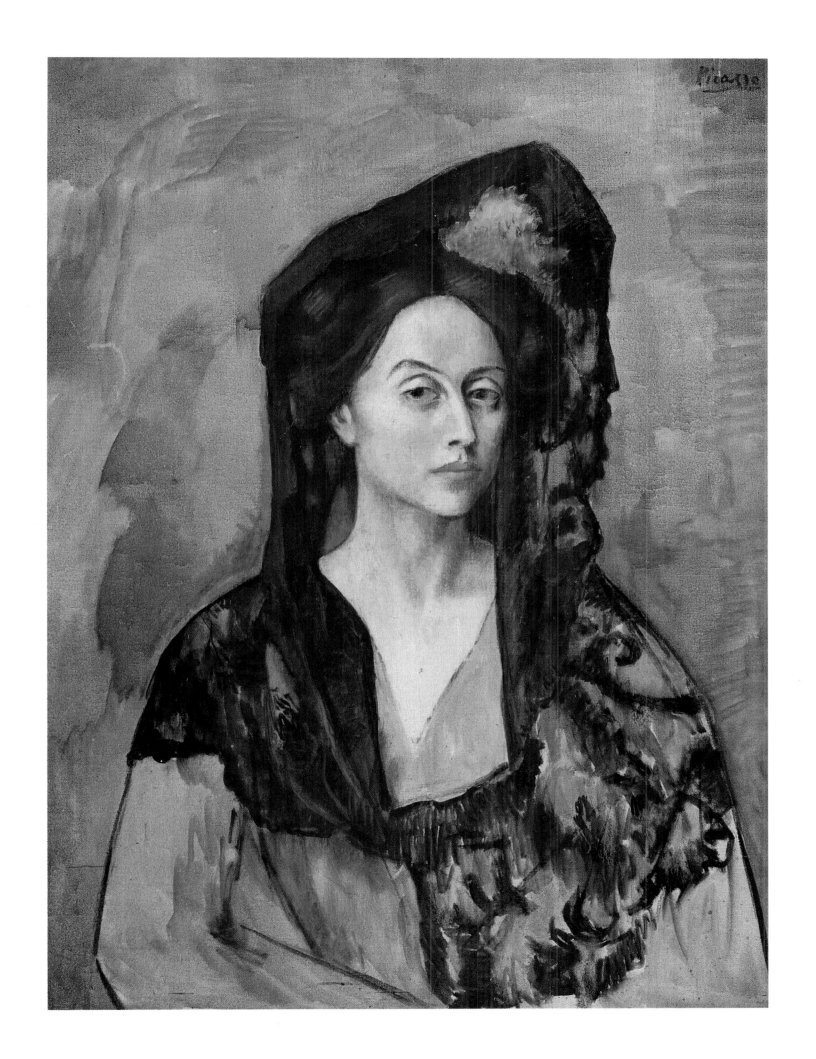

Woman with Fan, 1905

100.3 × 81.2 cm, National Gallery of Art, Washington

With her inscrutable expression and haughty bearing, *Woman with Fan* represents the end of sentimental painting, even if Picasso was not yet aware of it. He only returned to story-telling once more with *The Death of Harlequin* in 1906. From now on his painting was concerned entirely with form. Only the silhouette mattered, and he represented it accordingly. There was no longer any external view-point in his painting.

The facial expression and psychological depth in *Woman with Fan* are, once again, reminiscent of Velázquez. There is also a hint of the Egyptian, particularly in the way her proud nature is represented in profile. The treatment of light virtually transforms her face into a mask. Picasso has achieved depth for the first time. He has eliminated all superfluity in order to tap the essential. From this basis he was to build a pictorial revolution, the beginnings of which are imperceptibly present in *Woman with Fan*.

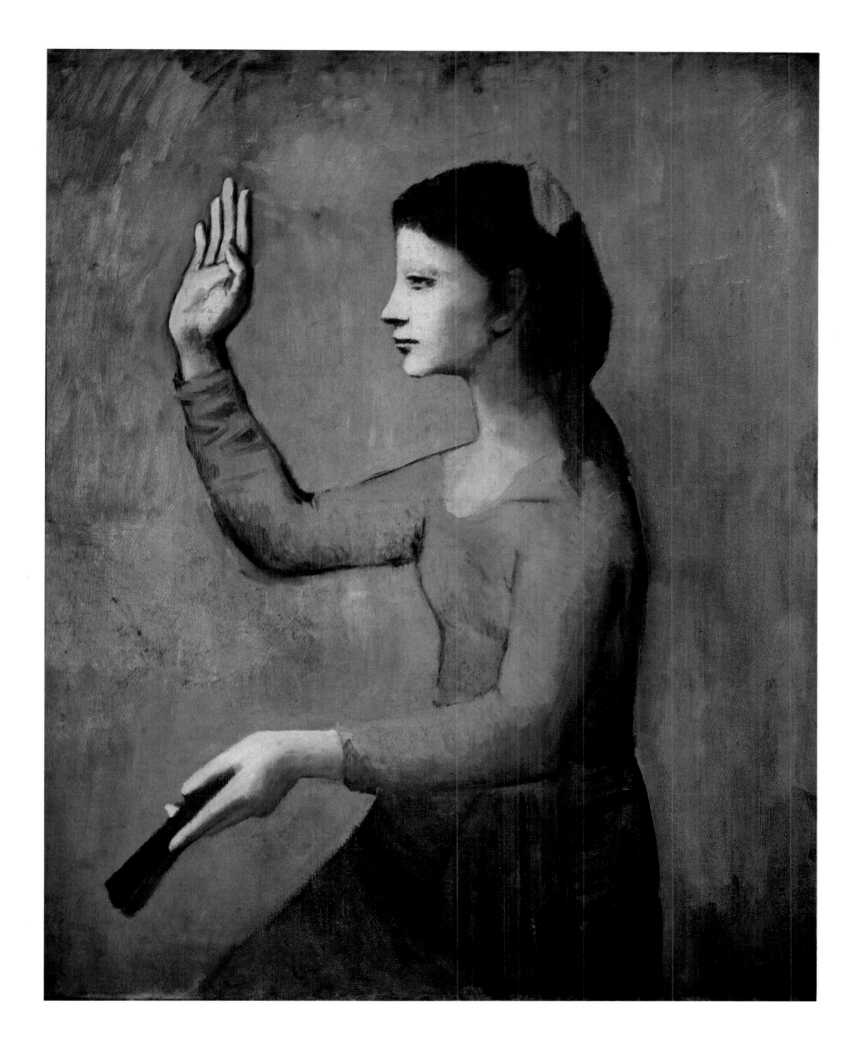

Portrait of Gertrude Stein, 1905–6

99.6 × 81.3 cm, Metropolitan Museum of Art, New York

In the summer of 1905, Gertrude and Leo Stein were introduced to Picasso and his studio by a young writer, Henri-Pierre Roché. Gertrude and Picasso soon became friends. She was, nevertheless, slightly surprised when he asked her to pose for him, as Picasso at this time rarely used models. She graciously accepted.

'I was, and still am, pleased with my portrait. For me, it is me. It is the only reproduction of myself which is still me.' Stein could not have praised him more highly. Picasso required more than eighty sittings, only to erase her head at the end of them! That summer he went to Gosol in Spain. Here he found a new way of painting, both cruder and purer, and doubtless influenced by his rediscovery of the primitive life and its secrets. Picasso had not made Gertrude Stein pose so often without learning something. In his initial conception of the portrait, he wanted to express the same objectivity with which he had invested the nudes he painted at the time he completed Stein's portrait. Returning to Paris, Picasso finished his painting with no further contact with his subject. He conferred on her the image of a mask, both impassive and expressive, which succeeded in making her more real than nature.

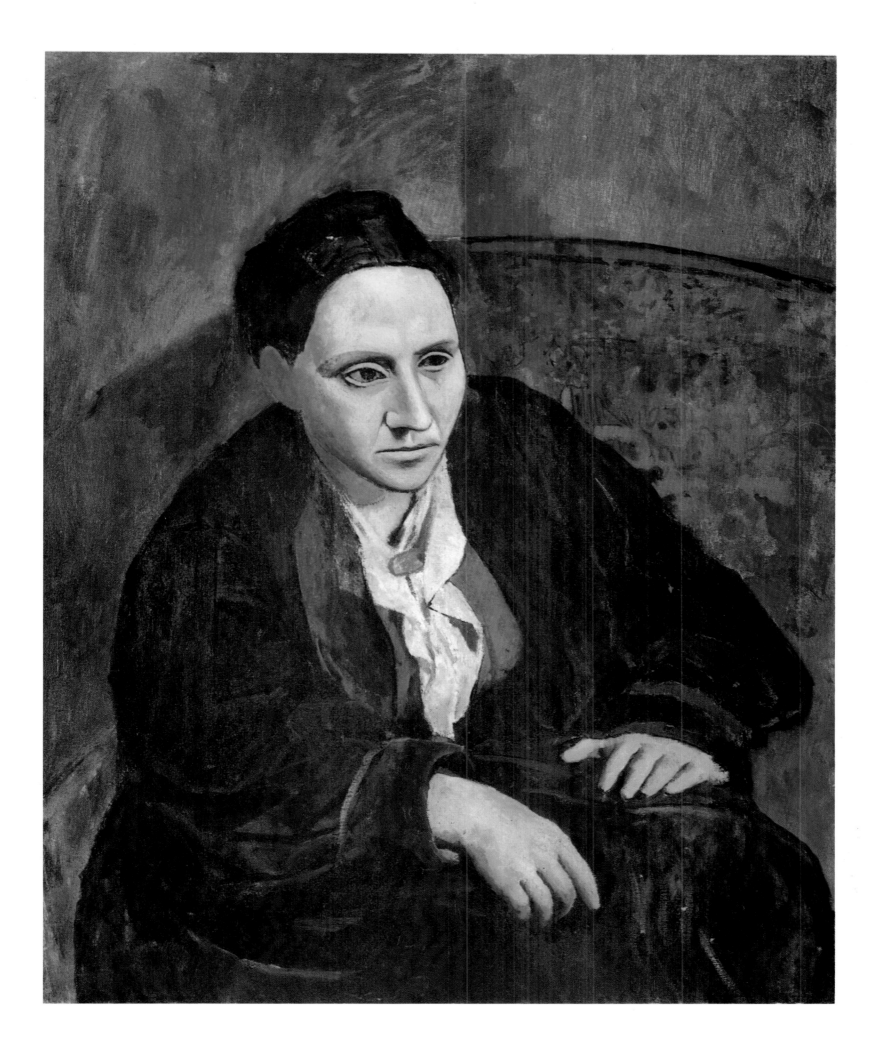

Two Brothers, 1906

80 × 59 cm, Picasso Museum, Paris

That summer, Picasso took Fernande to Barcelona to introduce her to his family. They then left for Gosol, a mountain village in High Catalonia, only accessible by mule. Despite the time he spent exploring the mountains, Picasso executed a prodigious number of canvases in his new 'classicized' style.

The theme of the two boys, with their finely-drawn faces and thoughtful expressions, and the presence of the drum are a residue of the circus world. In contrast to the flat silhouettes of the previous year, volume has reappeared, crafted in warm tones of pink, ochre and grey, the earth of the Catalan village. *Two Brothers*, which dates from the beginning of Picasso's stay in Catalonia, is the first painting in the 'classicized' style which he developed that summer. Their nudity is a reference to the statues of classical antiquity.

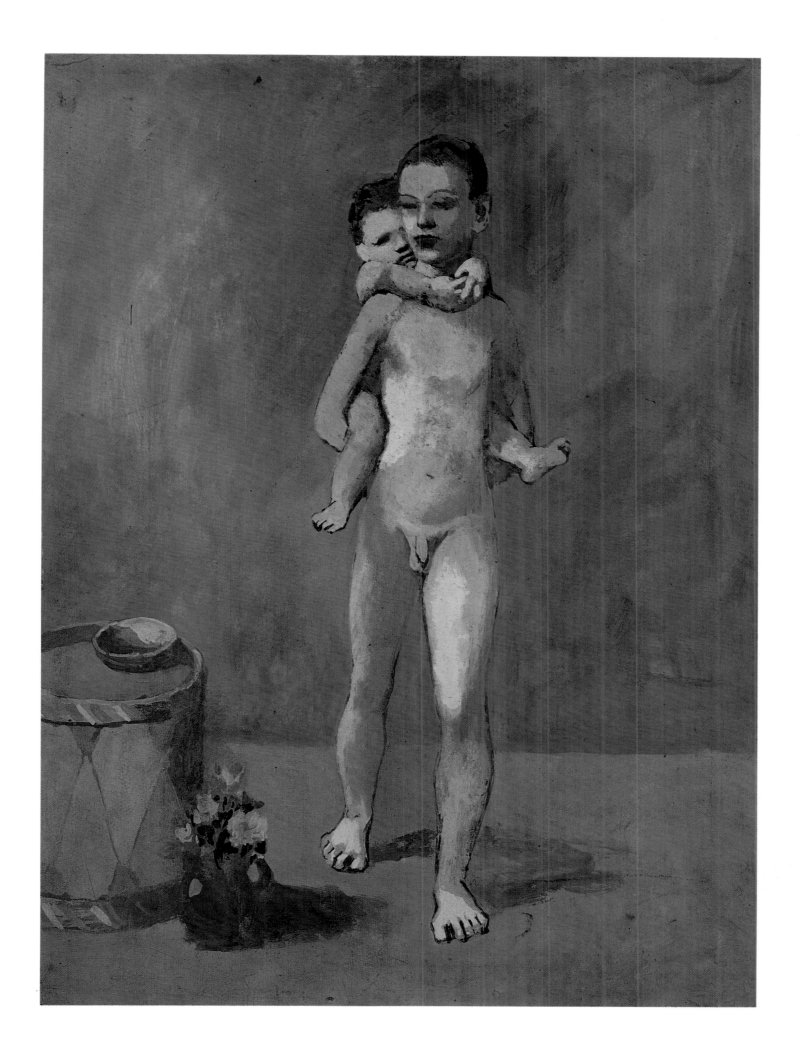

Self-Portrait, 1907

50 × 46 cm, National Gallery, Prague

Picasso did this self-portrait while working on his great canvas, *Les Demoiselles d'Avignon*. He was struggling to express the heads, faces and bodies of men and women in the way that he, Picasso, saw them. That he used his own face as a means of study is, therefore, hardly surprising. If we examine his numerous self-portraits in sequence, we can follow the evolution of his facial expression. 1907 was a crucial turning-point, the beginning of the great struggle that eventually gave rise to Cubism. Since the beginning of the winter, he had completed hundreds of sketches. He geometricized forms and, for the first time, succeeded in escaping all conventional ways of 'seeing'. There are still, however, traces of the Gosol period. We can see the same thickness of line, the crude ferocity of the flat surfaces. This self-portrait is both an experimental exercise and a self-examination. His look is fixed and his facial expression concentrated.

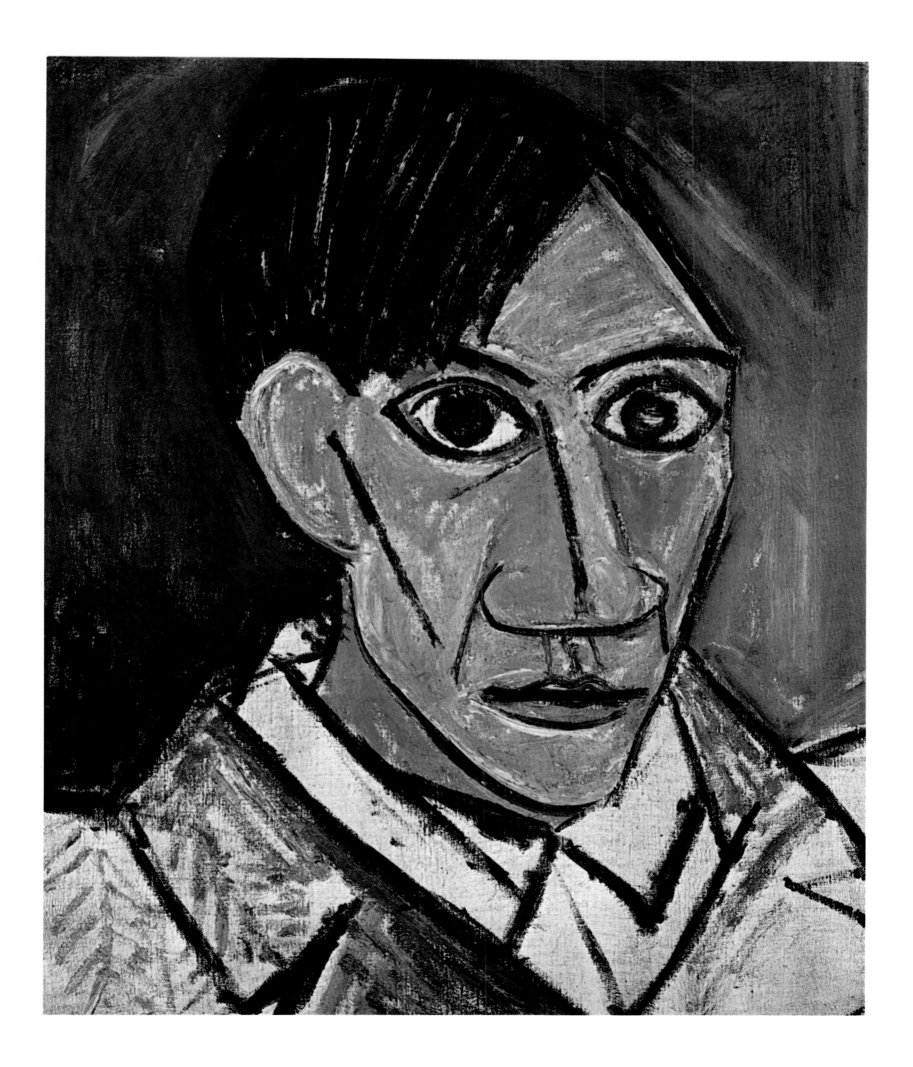

Les Demoiselles d'Avignon, 1907

243.9 × 233.7 cm, Museum of Modern Art, New York

There have been few real revolutions in the history of art, but *Les Demoiselles d'Avignon* is one of them. This painting is rightly regarded as the beginning of modern art. For the first time, a painter had radically transformed pictorial space. After several months of work and hundreds of preliminary sketches, Picasso brought this immense canvas to the first stages of completion at the beginning of May. He finished it in July. When he unveiled the painting, the reaction was one of consternation. Gertrude Stein recorded the event: 'it was a veritable cataclysm. I remember Shchukin, who really liked Picasso's painting, arriving at my place in tears: "what a loss for French art!"' The painting remained for several years in the studio, its face ignominiously turned to the wall. Only in 1937, was it finally revealed to the general public.

Studies show that originally Picasso had envisaged a composition with seven characters, two of whom were men, one a medical student, the other a sailor. In later studies he removed one of the women, changed some of the figures' posture and increased the angularity in their arms. Then the student became the woman on the left, his arm transformed into a breast, with a drape providing no more than token protection of her modesty. Finally the sailor disappeared, leaving us in the company of five women whom we can imagine as prostitutes, soliciting the observer with their insistent looks. There is a classical quality to the pose of the two central women. The faces of the two on the right have been disfigured by shading and, to make matters worse, the figure sitting with her back to us is presented full face, her chin resting on a deformed hand. We know from contemporary observers and from X-rays that Picasso reworked these faces on the canvas itself.

The influence of Iberian sculpture dominates the treatment of the three women to the right, particularly in the construction of their heads, the shape of their ears and the lines of their noses, whereas the two figures on the left are characterized by the influence of primitive Negro or Oceanic art.

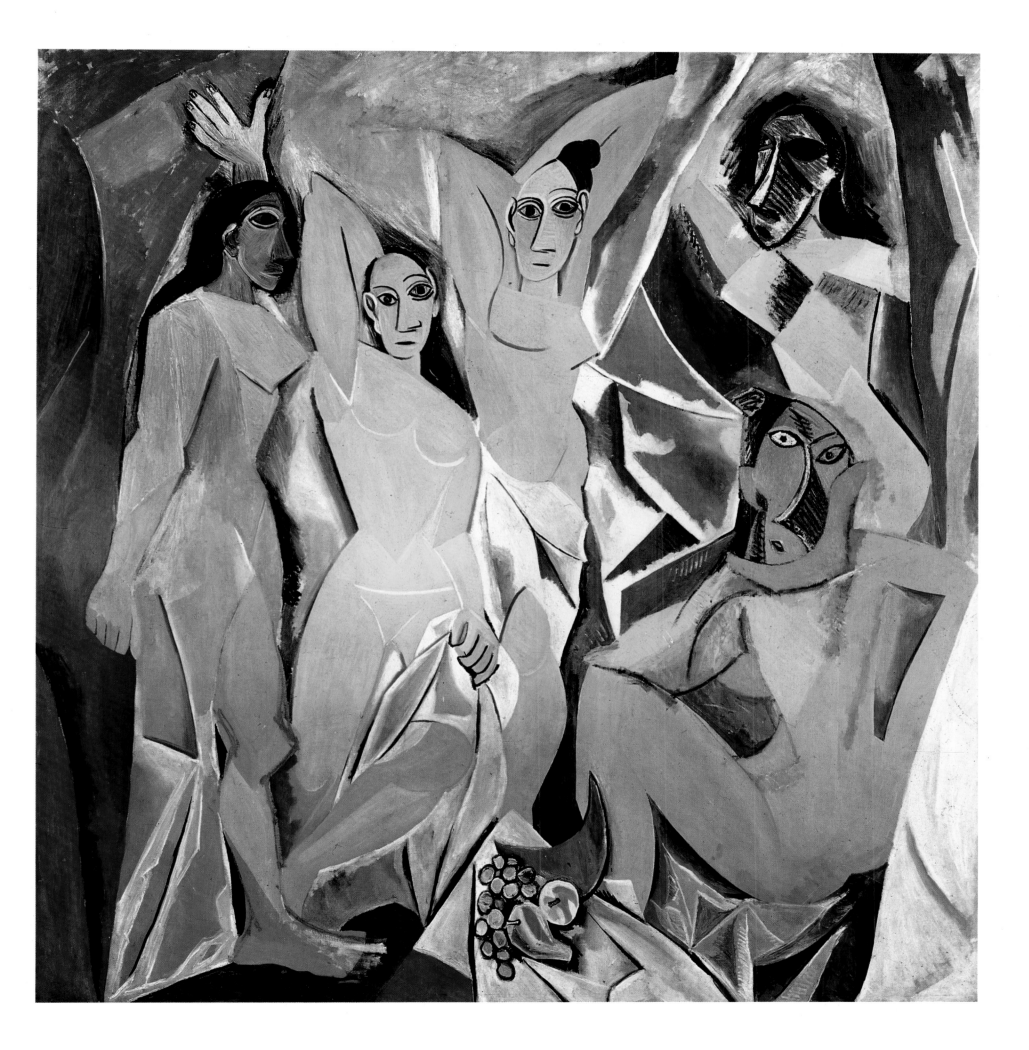

Dryad, 1908

185 × 108 cm, Hermitage Museum, Leningrad

The Autumn Salon of 1907 was given over to a Cézanne retrospective, while the Bernheim-Jeune exhibited his water-colours. Throughout his life Picasso regarded Cézanne as his master. After the outcry provoked by *Les Demoiselles d'Avignon*, he began a serious study of Cézanne's work, in an attempt to understand his thinking, and to go beyond it. *Dryad* benefits from this study, as well as being influenced by the discovery of Negro art. It is characterized by the geometric simplification of volumes and contrasting colours. The light plays delicately on the projections while depth is provided by variations in the intensity of light. *Dryad* and *Three Women* are works set apart from the painter's new-found preoccupations. They can be regarded as a magnificent post-script to *Les Demoiselles*.

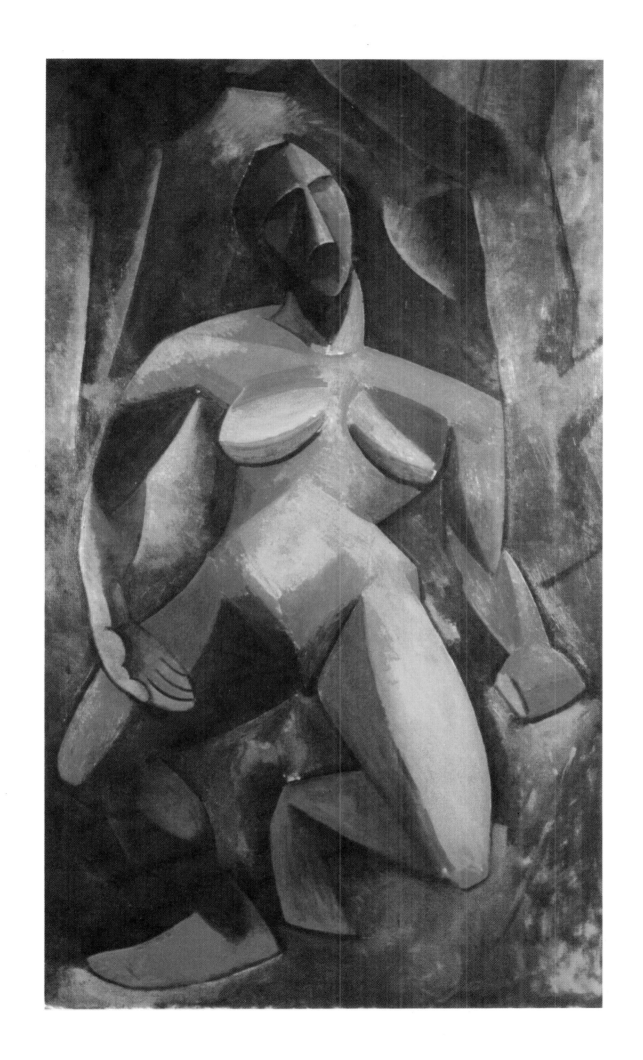

Factory at Horta de Ebro, 1909

53 × 60 cm, Hermitage Museum, Leningrad

Cézanne's presence was manifest in the minor revolution going on at Horta de Ebro. Picasso first went to this mountain village as a guest of Pallarès. 'Everything I know, I learned in Pallarès' village,' he said. When he returned in 1090, it was to lock horns with the spirit of Cézanne, to turn the Santa Barbara mountain into his own Sainte-Victoire. Here, in fact, he assimilated Cézanne's thinking and went further. Cubism, though still in its hesitant stages, had its beginnings in the landscapes of Horta de Ebro. The forms Picasso saw in nature became facets in an agglomeration of crystals. Everything is expressed by means of these luminous, almost metallic facets, bathed in a crystalline light. By the end of this process, Picasso had attained the geometric purity of Negro masks. But, more importantly, this was the first time he had shattered the contours of volume. From this starting point, he went on to invent the fragmentation of surfaces into facets which react differently to the light, and which, taken together, re-create shape and volume. Even at its high point, Cubism was based entirely on these ideas.

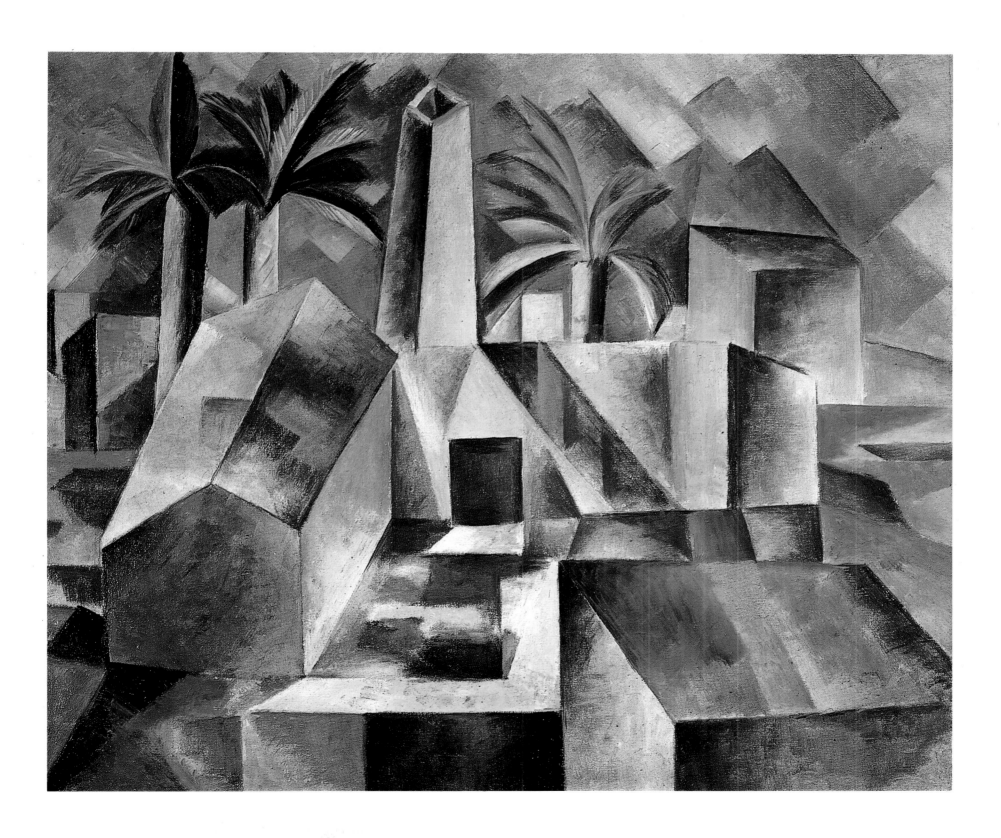

Portrait of Daniel-Henry Kahnweiler, 1910

100.6 × 72.8 cm, Art Institute, Chicago

This painting is characterized by its monochromatic use of grey, brown and ochre, and by the fragmentation of shapes into facets and geometric planes: a bottle on the table to the left, a sculpture from New Caledonia, gloved hands and the button of a jacket. Finally there are the corporal elements, the eyes, the nose, the hair. We do not immediately recognize Daniel-Henry Kahnweiler. We have to reconstitute the portrait by interpreting the information it gives us. For the first time, Picasso had started from the basis of discontinuity, treating his model as a three-dimensional structure made up of disparate elements. The acceptance of this discontinuity forced him to penetrate unknown space, which might vanish with the slightest error of judgement. This is not a theoretical solution, but a discovery which permitted him to push the fragmentation of surface further than the coherence of contour would allow. It was the result of a summer of research to which Kahnweiler was witness, as he wrote: 'the great step has been made. Picasso has exploded homogeneous form'.

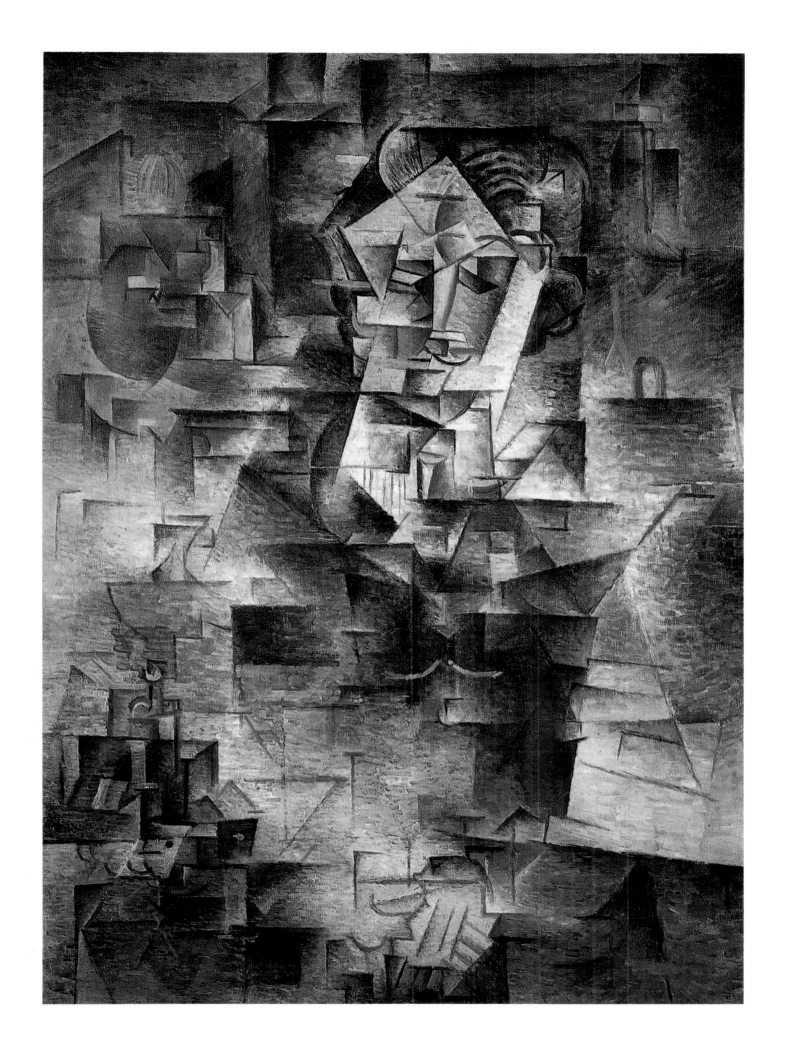

Still Life with Cane Chair, 1912

29 × 37 cm, Picasso Museum, Paris

Still Life with Cane Chair is one of those crucial, almost legendary, works which provided a turning-point, not only in the history of Cubism, but also in the history of twentieth-century art. It is the first collage in the history of painting. When he introduced a piece of wax cloth into his painting to signify the cane back of his chair, Picasso was throwing into question centuries of pictorial tradition, not only by resurrecting the old conflict between art and reality – why represent 'falsely' what can be presented 'really'? – but by going even further and raising the topic of the artist's materials themselves. With this first collage, Picasso was actually introducing the idea of a pictorial space capable of absorbing any foreign body, objects from the 'real' world, anything from outside painting. The full extent of his discovery was realized some six months later, when he established a decisive transformation in painting with pasted cut-outs.

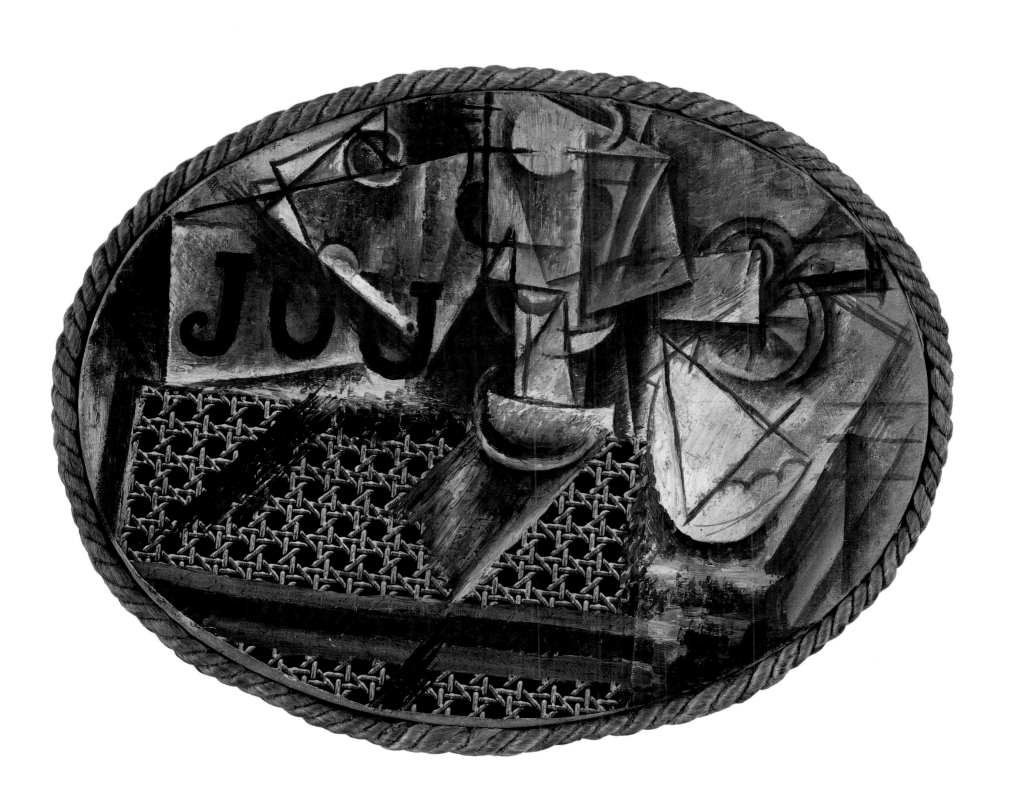

Violin and Sheet Music, 1912

78 × 63.5 cm, Picasso Museum, Paris

After the momentous invention of the collage, which permitted the use of all manner of materials, Braque and Picasso began working with pasted paper. They cut up, glued, and assembled anything that came to hand: newspaper, wallpaper, music paper. The shapes of the cut-outs are always simple, more often than not rectangular. Their use is critical to the evolution of Cubism. It allowed colour to be reintroduced in order to suggest a certain depth by superimposing different planes. It answered a profound need to explode the accepted canons of art in order to appropriate the concrete realities of an industrialized world.

The use of pasted paper can be divided into three distinct phases. The first, to which *Violin and Sheet Music* belongs, employs a framework, either painted or drawn, which sets up a dialogue with the pasted pieces of newspaper, coloured paper or, as in this case, sheet music. The second period, between February 1913 and the early spring of that year, saw the use of the real object as a form of expression, clearing the way for what was to be called synthetic Cubism. In the third period, between March 1914 and the beginning of summer Picasso experimented with the effect of materials. In the future he was only to use pasted paper in a purely chance fashion.

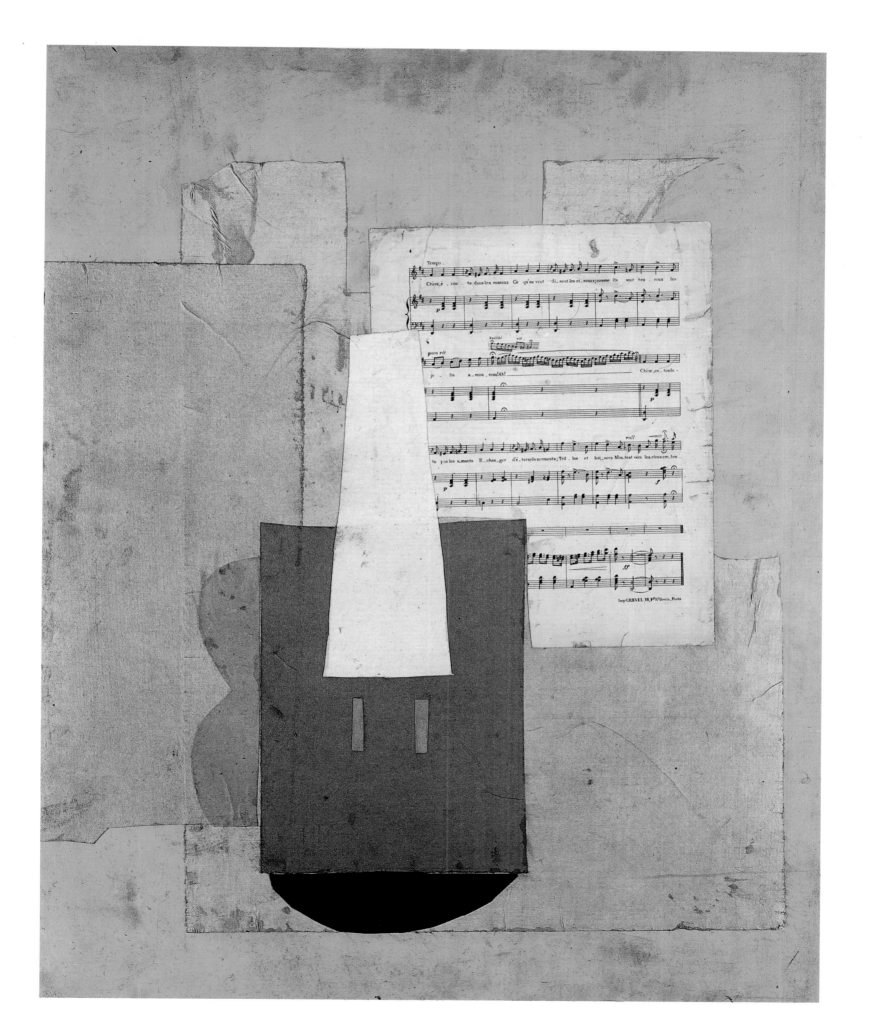

Portrait of a Young Girl, 1914

130 × 97 cm, Musée National d'Art Moderne, Paris

All the canvases of 1914 were painted in the same spirit of unbridled lyrical fantasy. *Portrait of a Young Girl*, in saturated green, is one of these. It is remarkable for the free reign given to its inherent humour. The composition is based on a single, supple rhythm which controls the torso, the movement of the arm and the form of the boa around her neck. The artist has made rich use of elements of collage, together with certain Cubist processes, pasted paper in particular. But, by representing them in paint, he robs them of their original meaning. From this moment on, the painting becomes a parody. The edges of certain surfaces have illusions of shadow, giving the impression that they are actually glued onto the canvas.

By now, Picasso has pushed the redefinition of form so far that his paintings are beginning to show signs of the kind of free drawing he was to use at the end of the 1920s and in his 'Surrealist' period in the 1930s. The prolepsis evident here is even more striking when we consider that the basis of Surrealist painting was the affirmation of flexible, organic forms contrasted with Cubist geometry.

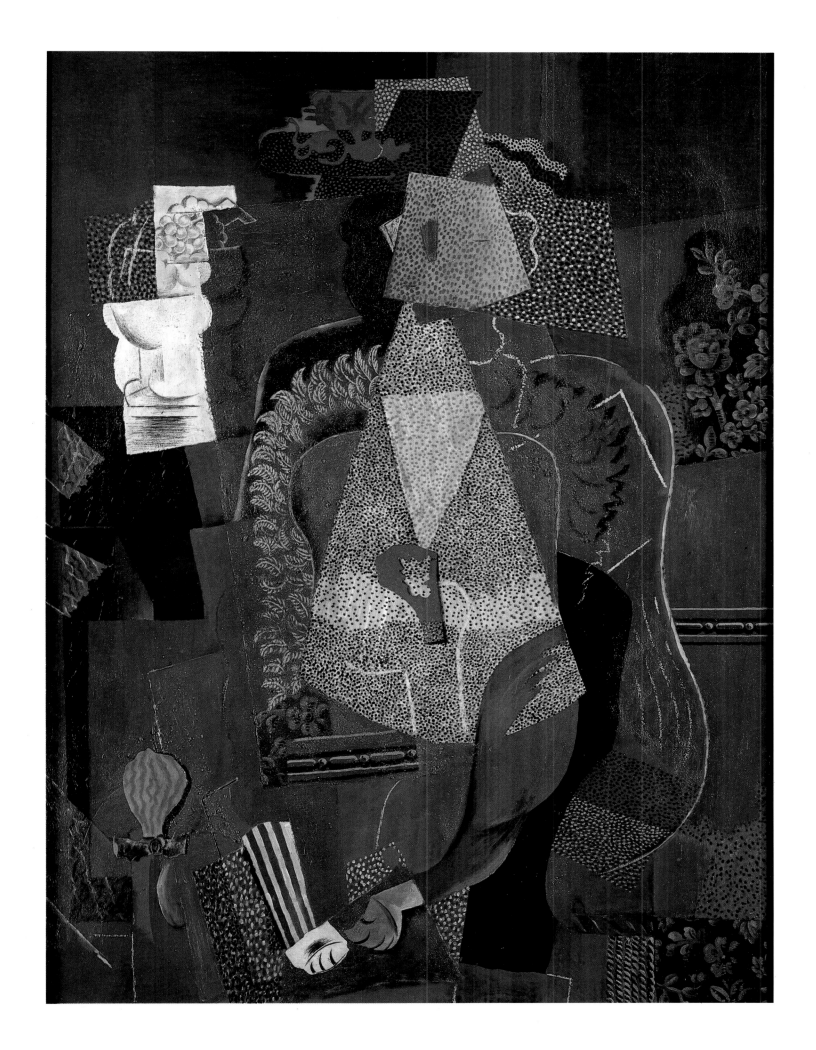

Portrait of Olga in an Armchair, 1917

130 × 88.8 cm, Picasso Museum, Paris

Picasso's meeting Olga Koklova in Italy while he was putting the final touches to *Parade*, gave him the hope of a new love, a hope which was both serious and respectful. This portrait is the first that Picasso painted of the woman who was to become his wife and the mother of his son Paulo. Judged in terms of the photograph which he used as model, the resemblance is astonishing.

Despite the obvious references to the great portraits by Ingres, *Portrait of Olga in an Armchair*, is entirely unclassical. On the contrary, it makes use of Surrealist techniques, marrying them to a conventional approach. The deliberately unfinished quality of the armchair, the sketchy background, are contrasted with a purity of line and minute detail, particularly in her dress. The entire image seems to be floating in space. Because of the absence of depth, Olga does not seem to be really sitting down. She has the absent, slightly melancholic air which characterizes her in all Picasso's work.

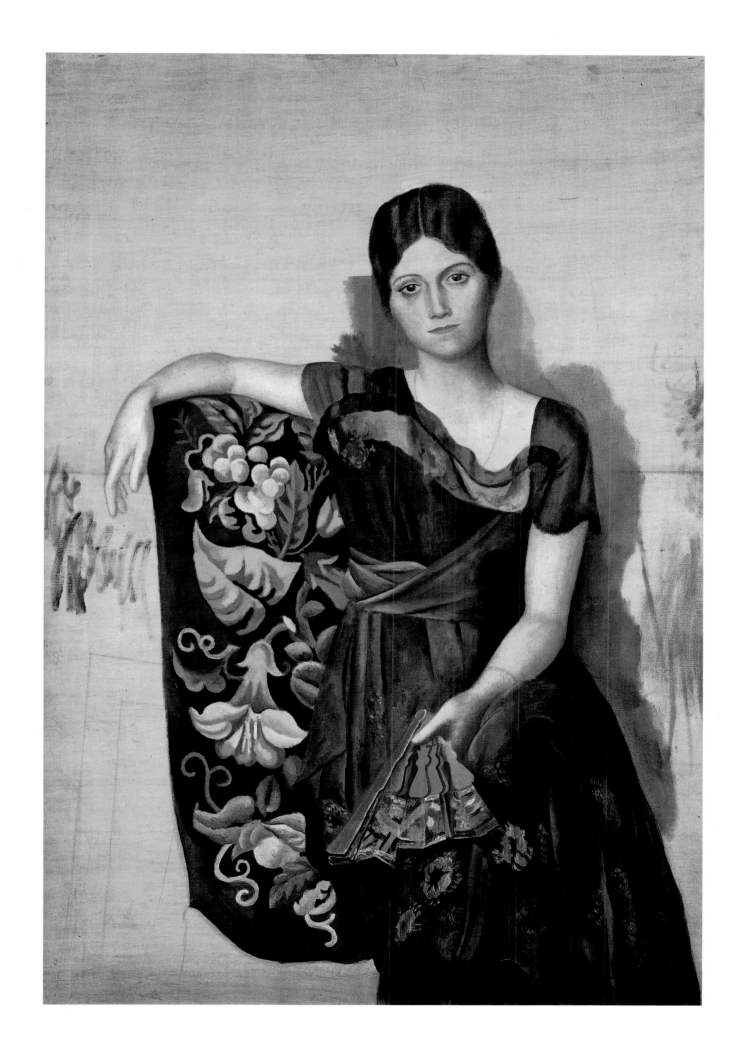

The Bathers, 1918

27 × 22 cm, Picasso Museum, Paris

From 1918 on, Picasso spent practically all his summers by the sea. With this first visit to Biarritz, a new theme entered his work: bathers. Although this theme recurs throughout the history of art, from Boticelli's *Venus* to Cézanne's *Bathers*, it was given a new lease of life with the contemporary fashion for swimming in the sea. Picasso, the indefatigible observer of the world around him, was bound to react to this new phenomenon.

Picasso always used this little painting, remarkable for its boldness of colour, as a point of reference. The prosaic character of these modern Venuses moulded in their striped bathing-suits, the biomorphic shapes of the rocks and pebbles, the static sea and the ecstatic antics of the woman with hair like tentacles combine to give the scene a Surrealist atmosphere. The sinuous female bodies possess a grace rare in Picasso, and mark the first move towards an expressionism through elongation which evokes both Ingres and El Greco and suggests a conflict between their particular styles.

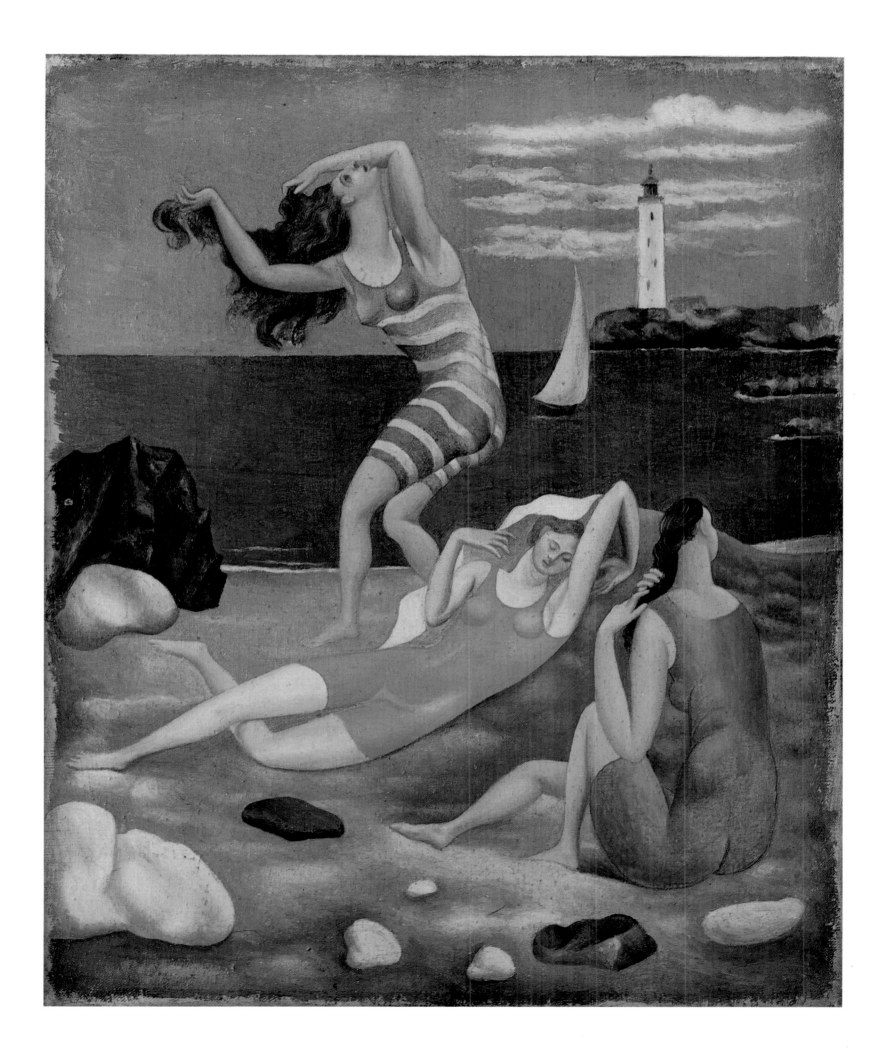

Three Musicians, 1921

200.7 × 222.9 cm, Museum of Modern Art, New York

A masterpiece of poetic humour, *Three Musicians* is also a testament to technical skill. It is the first work in which Picasso attempted a composition with three figures within the rigorous constraints of synthetic Cubism. The flat surfaces of colour, simple and rectilinear, are laid out in such a way that everyone can see what they stand for, but it is the hieratic nature of the three masked figures, visible even in the smallest reproduction, which is astonishing. The effect of monumental scale created by the construction of their mass is exaggerated by its comparison with the musicians' tiny hands.

Even more fascinating is the fact that when we look at the *Three Musicians*, we instantly hear a kind of spontaneous music. Possibly it was Picasso's first experience of fatherhood that put him in such a good mood. Olga had born him a son in February 1921. That summer, instead of returning to the coast, Picasso rented a spacious villa at Fontainebleau. It was here that he painted his two versions of *Three Musicians*, which can be seen as the flowering of synthetic Cubism, enriched by his recent experiences as a theatrical designer.

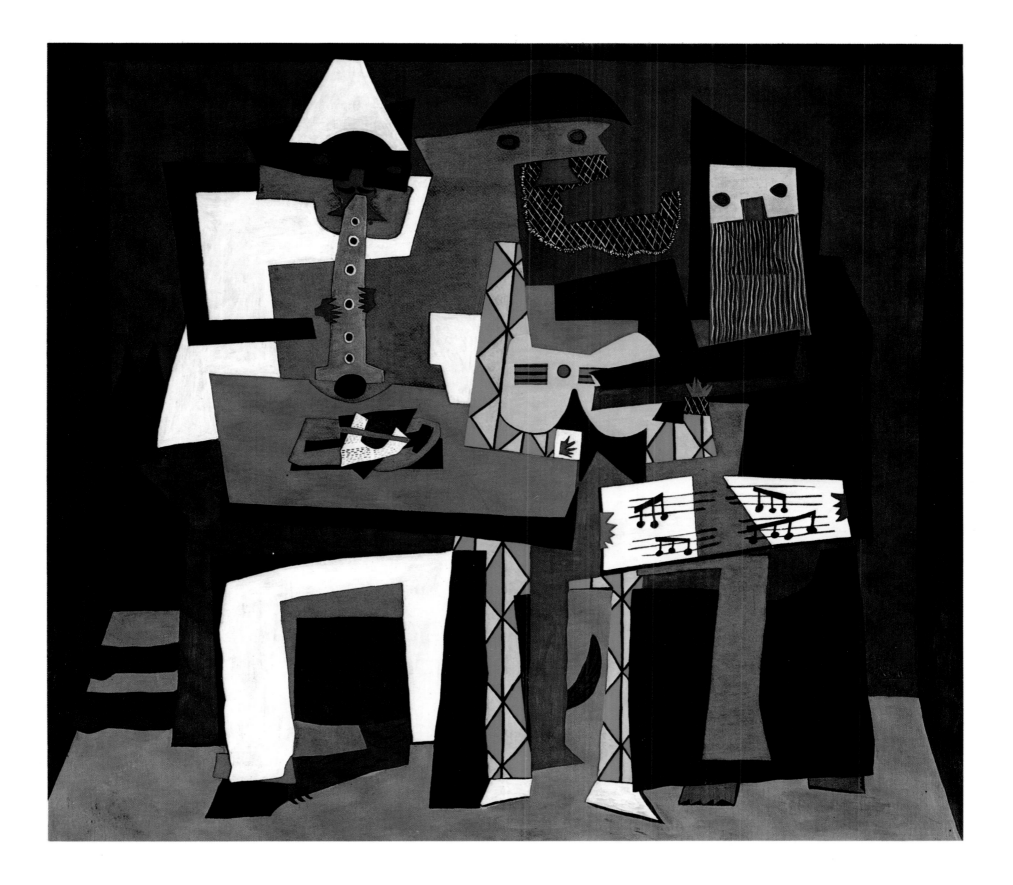

Large Bather, 1921–2

182 × 101.5 cm, Walter-Guillaume collection, Paris

From 1921 to 1922, Picasso painted a series of giant women. They all have the same well-defined eyes with vacant expressions, noses which extend from the forehead, and outsized hands and feet in relation to their bodies. They have the weight of statues. These exaggerations of size perfectly convey a symbolic image of woman, but they are also a function of the pictorial structure. Once again, Picasso offers a new way of seeing, of perceiving another reality. Confident in his new-found freedom, and conscious of the reality of the painting as object, he spreads the legs and arms across the surface of the canvas, inflating them until they are all equally important, equally solid, filling all the available space in the painting. The white draped garment is a deliberate reference to antiquity. *Large Bather* was a powerful attempt to rid painting of the contemporary academism which disguised the meaning of ancient forms. Picasso is demonstrating that it was not these forms themselves that were obsolete but, rather, the way in which they were viewed. In 1930, Picasso confirmed this opinion: 'Art has neither a past nor a future. Art which is incapable of affirming itself in the present will never be achieved. It is not to the past that Greek or Egyptian art belongs: it is more alive today than it was yesterday.'

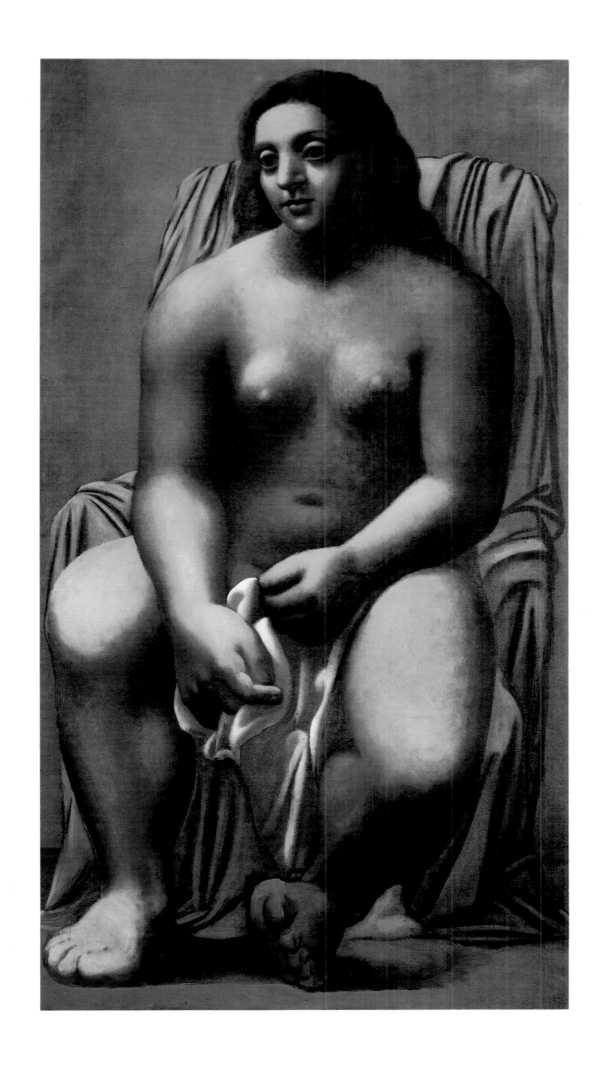

Two Women Running on the Beach, 1922

32.5 × 41.1 cm, Picasso Museum, Paris

This monumental gouache in miniature format was used as décor for the *Train bleu* (1924), a ballet-operetta by Diaghilev with libretto by Jean Cocteau and music by Darius Milhaud. The action takes place on a fashionable beach and is a celebration of life in the open air, naked bodies and sport. The originality of these *Two Women Running on the Beach* lies in its incredible sense of movement. Despite the huge size of the runners, they seem to be swept along by the speed of their race, on the point of taking off. To achieve this effect, Picasso employed various formal devices: their hair and clothes floating in air; the light which gives a delicacy to their bodies; the held-back head of the woman who resembles the goddess Thetis in Ingres' painting; the empty face of the other; the robustness of the bodies and, in particular, the direction of the diagonal and horizontal lines of force which give the composition its structure.

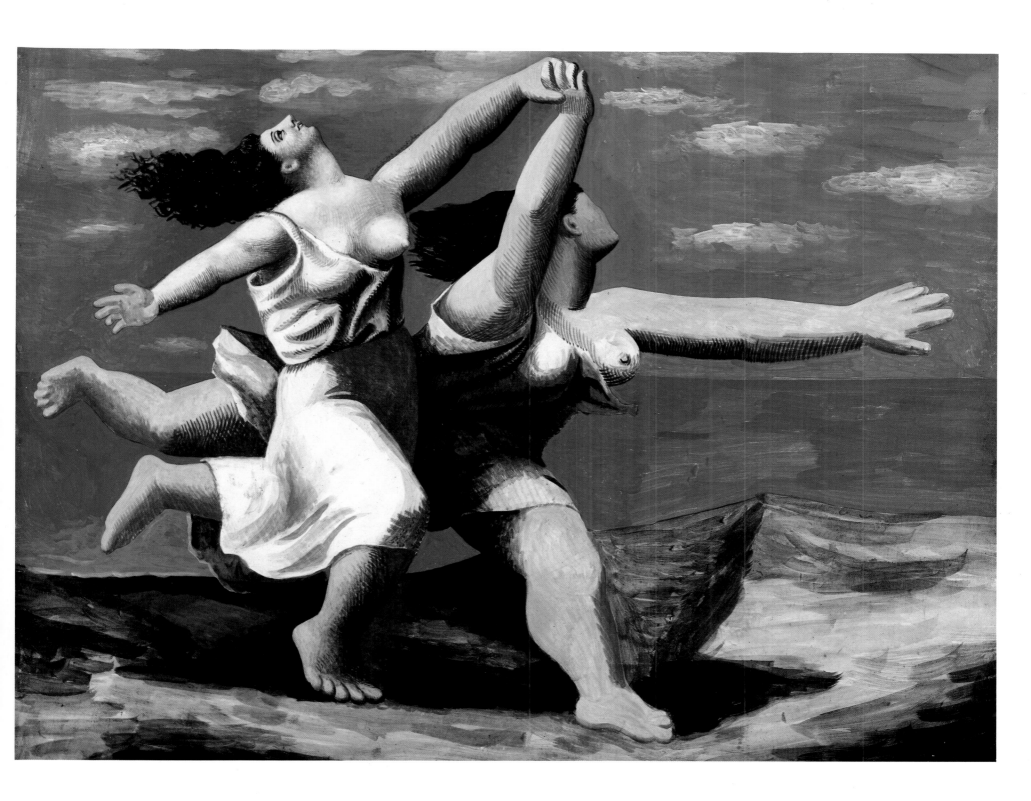

The Flute of Pan, 1923

205 × 174 cm, Picasso Museum, Paris

Picasso depicts these two men as young classical shepherds in a Mediterranean context. The simplicity and nobility of the composition have brought *The Flute of Pan* unanimous recognition as a masterpiece. Every aspect of this remarkably ordered canvas is invested with purity and grandeur. There is 'not a single gesture which does not serve the fruition of its plastic purpose,' wrote the poet Pierre Reverdy. 'Not a head, a body or a hand which is not, by virtue of its form or position, an element uniquely useful to the expression of the whole, with no other meaning outside the plastic constitution of the painting.' Somewhere between Poussin's *Arcadian Shepherds* and Cézanne's *Bathers*, Picasso reinvented a new source of elegiac and pastoral inspiration. We rediscover the theme of the two adolescents and two friends. Picasso's recent work in the theatre is evident in the theatrical way in which the two protagonists have been set against the scenic background.

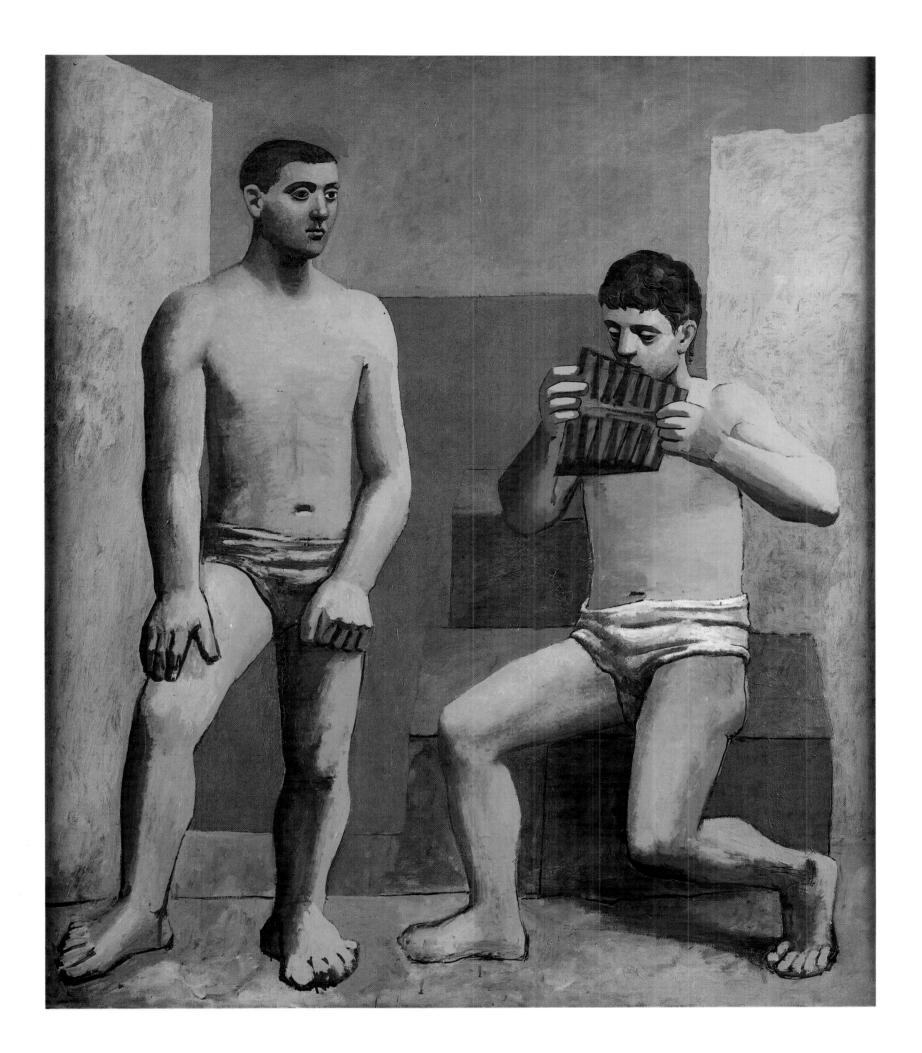

Harlequin (Portrait of the painter Jacinto Salvado), 1923

130 × 97 cm, Musée National d'Art Moderne, Paris

In mid-February 1923, the acrobat re-entered Picasso's work, in the recognizable form of Harlequin. Picasso brought out the old costume and lent it, this time, to his friend, the Catalan painter Jacinto Salvado. As usual, Picasso painted a whole series. 'Nothing seems to change but, in fact, everything changes,' wrote Gertrude Stein. 'Picasso is in another Harlequin period. This time a realist period, not sad, less youthful, a period of calm. He is content to see things like everyone else sees them. Not completely like everyone else; but almost.' Two three-quarter face Harlequins are indistinguishable apart from their expressions. The Harlequin painted in profile is the most developed. Yet another, *Harlequin in the Mirror* is a full-face portrait, remarkable for the assymetry of the shoulders.

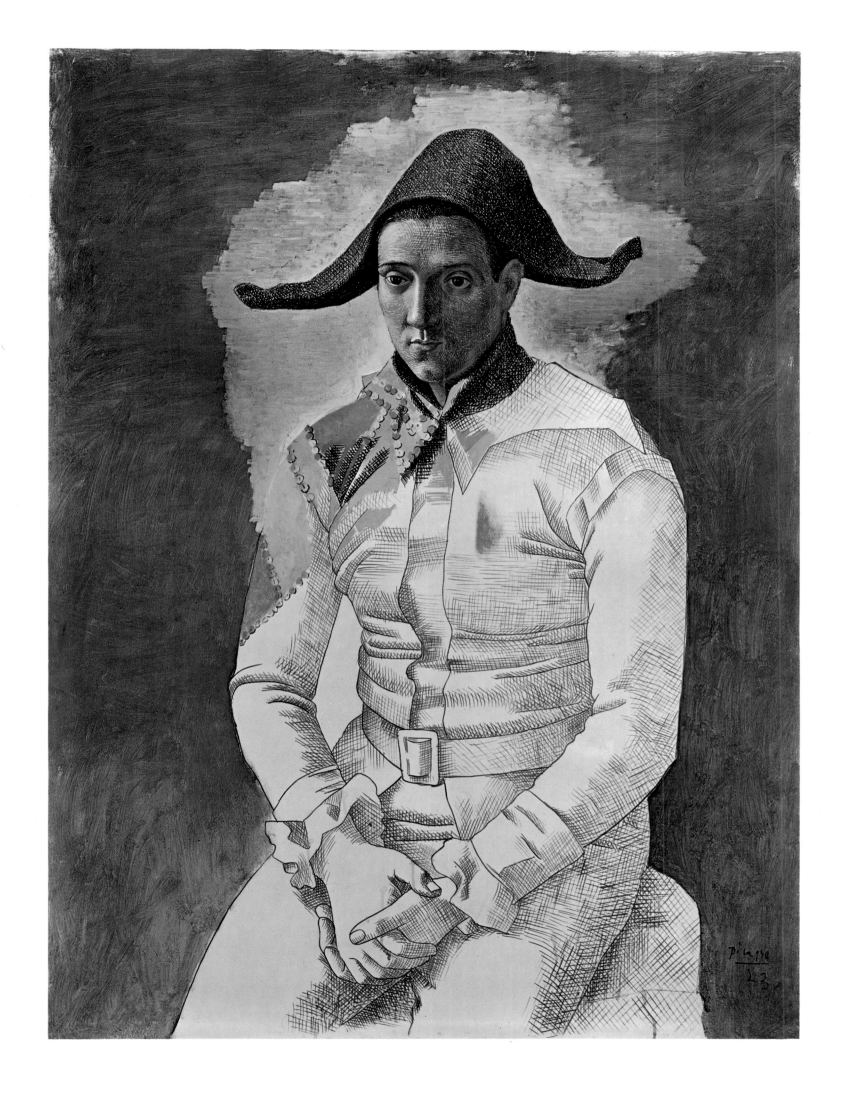

Paulo as Harlequin, 1924

130 × 97.5 cm, Picasso Museum, Paris

Picasso always had a particular gift for expressing reality as perceived by children and adolescents. He reveals great tenderness towards his young son, and with a greater honesty than any other painter would admit. Picasso conferred these moments of grace onto all his children. He succeeded in fixing what he knew to be a fleeting moment. Here, Paulo is 3 years old. He is wearing the Harlequin costume of which his father was so fond, and in which he had even painted himself. The incomplete nature of the painting (the child's feet are only drawn in) immediately belies its apparently conventional nature. The neutral grey-beige background and the precision and complexity of certain details recall the portrait of Olga. Paulo's fragility and sense of unreality are accentuated by the instability of his posture. Like Olga, he is not sitting but seems to be placed flat against the dark background of the armchair, like a playing-card.

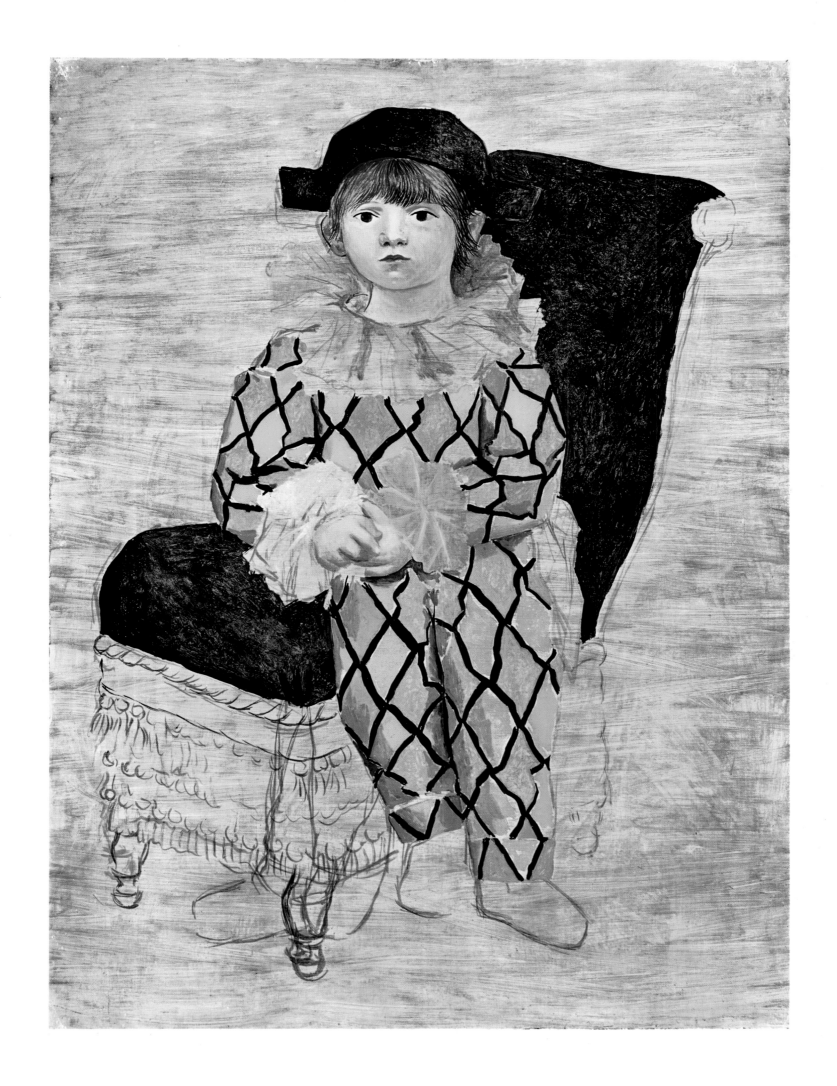

The Dance, 1925

215 × 142 cm, Tate Gallery, London

In the spring of 1925, Picasso joined Diaghliev and Massine in Monte Carlo for a short ballet season. Hopes for a new golden age, shared by so many just after the war, had disappeared, giving way to a sense of frustation. There was desperate violence accompanied by sinister forebodings. Picasso's private life was in turmoil. He and Olga had not succeeded in settling their differences. On top of all this, he had just learned of the death of his friend, Ramon Pitxot. The sombre, immobile profile of a man on the right of the painting is the ghost of the Catalan painter. He seems to be presiding over this spectacle in which the ritual dance is arranged like a crucifixion scene. The dancer at the centre with her arms spread provides the axis. For the first time since the great *Harlequin* of 1915, there is an explosion of violence beneath Picasso's brush, which recalls Breton's remark, 'beauty will be convulsive or not at all'. With its dislocated bodies, gandy colours and syncopated movements, it is both a frenetic dance of life and a ritualistic dance of death. *The Dance* announces a new freedom of expression. In the years that followed the human form was to be dismembered, not by the meticulous dissection Picasso pursued during the period of analytic Cubism, but with a violence rarely equalled in the work of any artist.

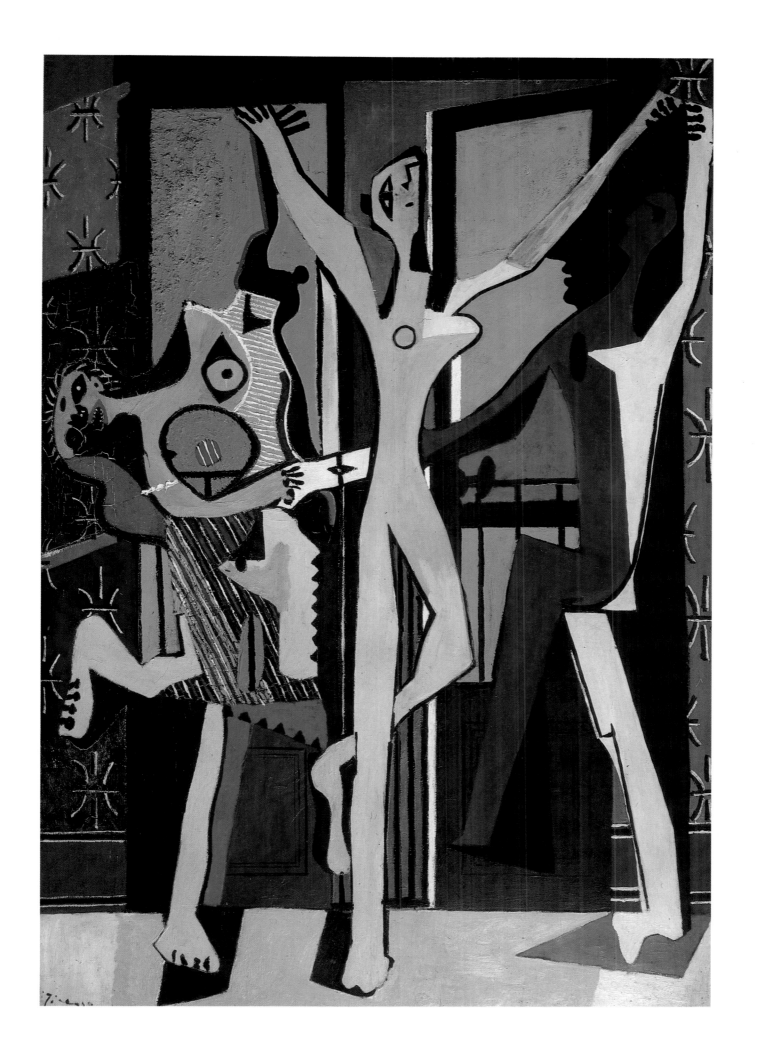

Painter and Model, 1926

172 × 256 cm, Picasso Museum, Paris

The painter and his model constitute one of the essential themes in Picasso's work. It first appeared in 1914, was developed in the *Studios* series of 1927 to 1928 and in the *Vollard Suite*, and saw its final manifestation in the cycle he painted in the 1960s.

This large canvas in grey and white is the starting point for infinite stylistic and thematic variations. The artist on the right of the painting is clearly identifiable by his palette. The female model on the left is reduced to a tiny head, a large neck, two hands, uneven in size, and an enormous foot. Like automatic writing, which allowed the pencil to follow its own, uncontrolled direction, this pictorial writing should be seen in the context of drawings and studies which Picasso made at this time to illustrate Balzac's *Chef d'œuvre inconnu*.

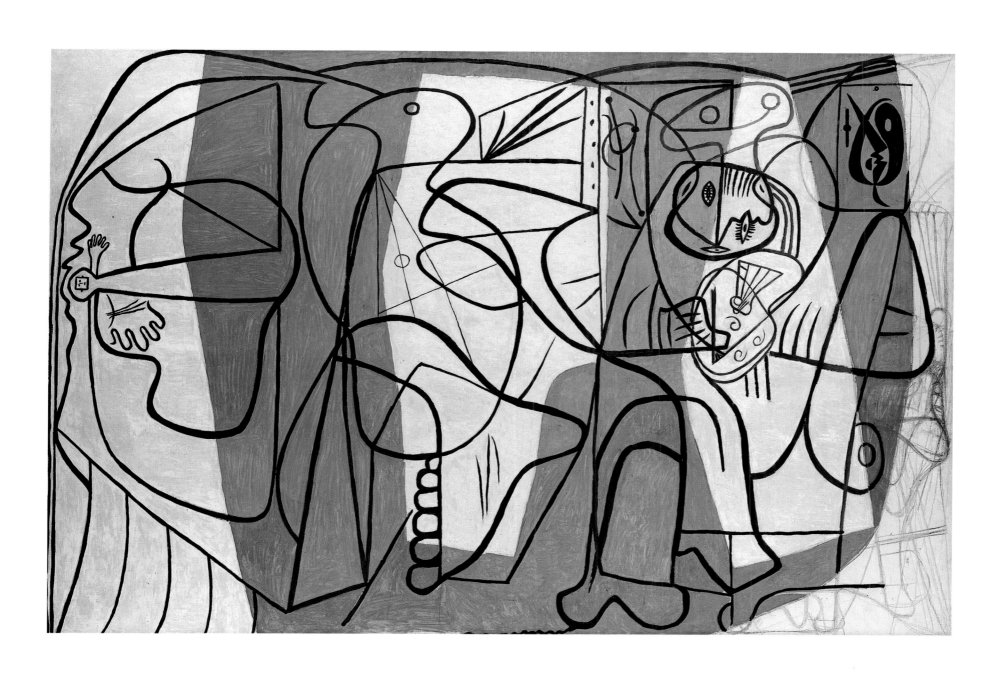

Woman in an Armchair, 1929

195 × 129 cm, Picasso Museum, Paris

There are certain paintings in which cruelty is essentially plastic. They can hurt through the very power of their image. *Woman in an Armchair* is one of these. It shows a woman screaming, with her head thrown back, her hair dishevelled, her menacing teeth, her monstrously deformed tentacular body, against a background of colours which also seem to be screaming. What has happened to the beautiful, melancholic Olga? The pictorial tension is all the more powerful in that the suppleness of the body and elasticity of the armchair are counterbalanced by the architectural force of the composition by the geometric framing of various parts of the figure, Picasso unhappy, angry and rebellious. This painting is clearly a vituperative expression of his relationship with his wife.

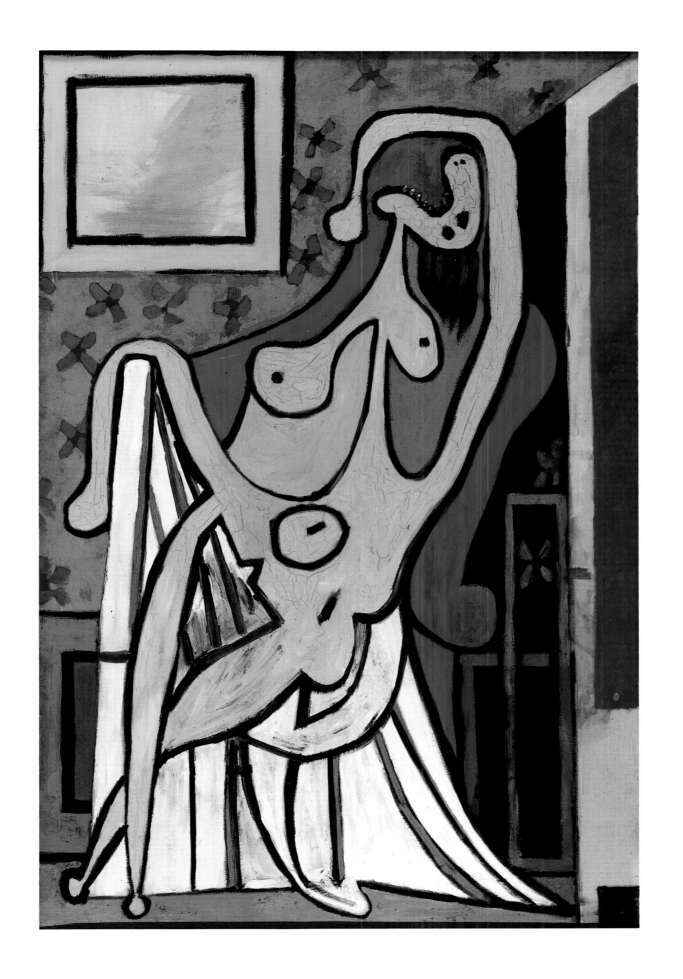

The Crucifixion, 1930

51.5 × 66.5 cm, Picasso Museum, P-

It is not surprising that, as a Spaniard, Picasso was eventually to launch an attack on religion. *The Crucifixion* was his vehicle. The dominant theme is Christian and the traditional symbols of the crucifixion are clearly present. Christ nailed to the cross stands out in grey against the black of the shadows. Around this central figure, we can make out two other crosses in the distance. The two thieves have just been brought down and their martyred bodies are lying on the ground in the bottom left-hand corner. In the foreground, two soldiers are playing cards for the clothes of Christ. The two yellow arms reaching into the air belong to Mary Magdalen whose head, leaning forward with its prominent nose, has become the head of a soldier. The complex Christian iconography is enriched by figures which belong to Picasso's personal universe. These demons bring with them an emotional charge which is theirs, and theirs alone.

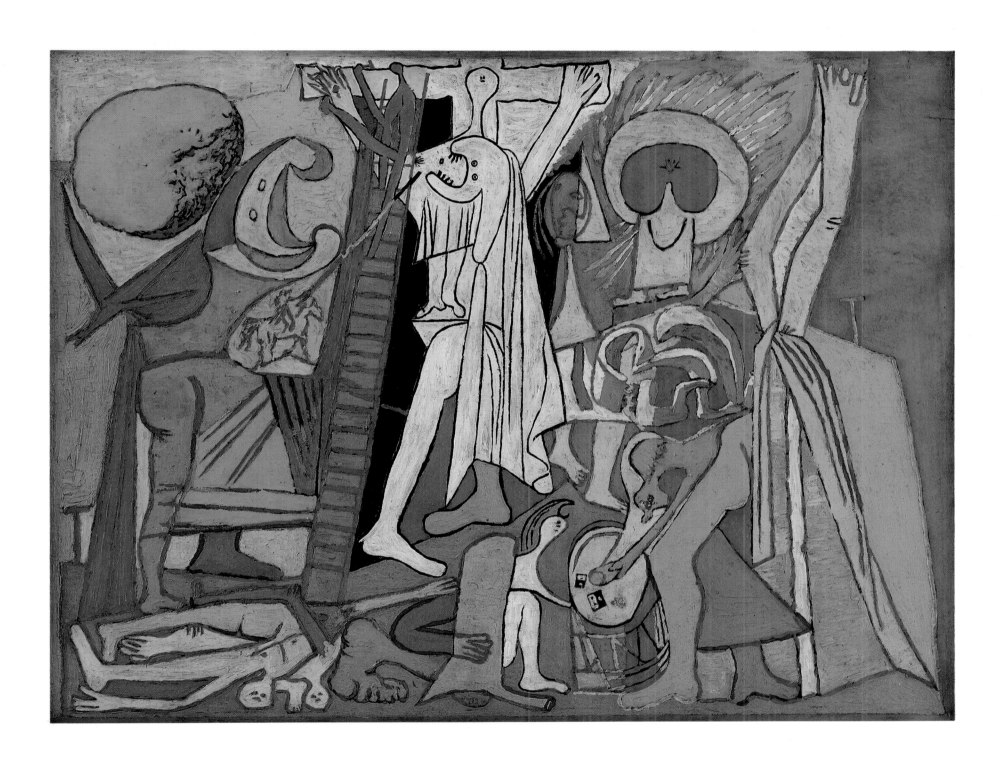

The Dream, 1932

130 × 97 cm, Mr. and Mrs. Victor W. Ganz collection, New York

Picasso is meditating, watching his recent young conquest asleep. He met Marie-Thérèse Walter, by chance, in the street. Enthralled by the 17 year old's freshness, he took her by the arm, introduced himself and announced: 'You and I are going to do great things together.' For a long time Marie-Thérèse was to remain a secret liaison, not appearing in his paintings until 1932 when, suddenly, she was everywhere, busting with her lover's happiness. 'How do you think an observer can live my painting as I have lived it,' Picasso said in 1939. 'A painting comes to me from afar; who knows how far; I devined it, I saw it, I did it, but even so, the next day, I cannot see what I have done myself. How can anyone penetrate my dreams, my instincts, my desires, my thoughts, which have taken so long to develop and to see the light of day, and comprehend what I have put into it, perhaps even against my will.' The dissociation of the two sides of the face in the extension of the moulding of the room, prefigures Picasso's later sculptures.

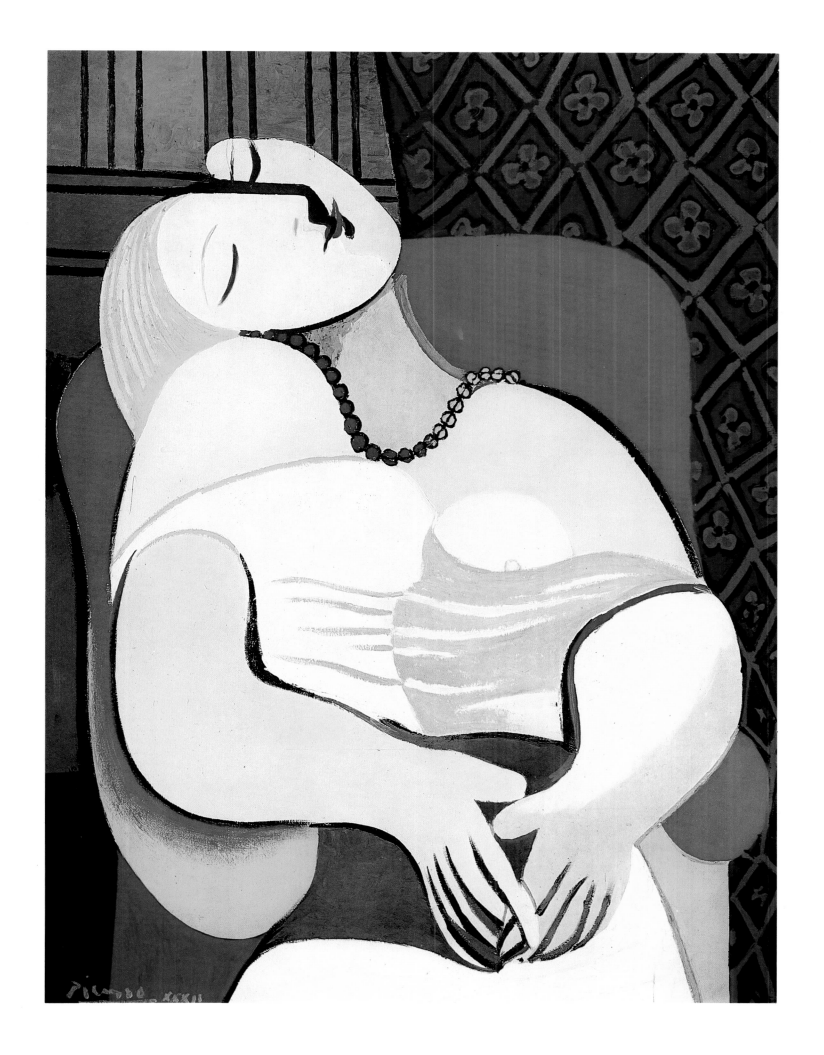

Bullfight, 1933

31 × 40 cm, Picasso Museum, Paris

The bullfight reminded Picasso of his childhood in Málaga, and of those Sundays spent in the arena listening to his father Don José explaining the technicalities of the combat. The earliest Picasso painting in existence represents a picador. He painted it when he was 8 years old. Everything about the bullfight attracted him: not only the vivid spectacle with its bright, sparkling colours, the stark contrast between light and shade, but also, and above all, the bloody ritual which brought man and beast together in their tragic struggle. Here, the toreador is dying alongside his horse, whose twisted neck reaches upward in a cry of agony, crushed by the centrifugal power created by the elliptical form of the bull. This scene occupies the whole pictorial space of the painting. The different treatment of the two parts, one detailed in high relief, the other flat and sketched, accentuates the forward projection of the animal. In the same year, Picasso painted another, similar painting, *The Death of the Female Toreador*. As in *Bullfight*, she dies in an attitude of ecstasy, representing Marie-Thérèse.

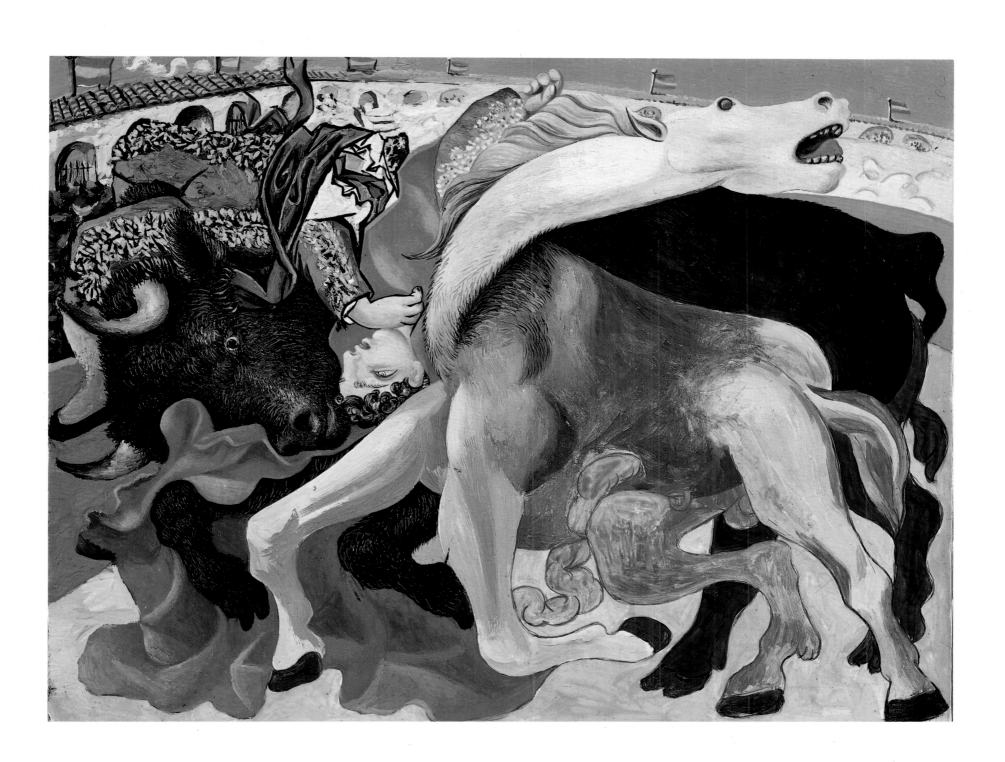

Nude in a Garden, 1934

162 × 130 cm, Picasso Museum, Paris

Marie-Thérèse is the paradigm of the sleeping woman. Here, her body is symbiotically linked to the plant world around her. Colours, material and forms come together to celebrate the sleeping lover. The body of desire becomes the body of the painting, the bright pink of the flesh, the green of the foliage. The suppleness and grace of this female nude are reminiscent of Matisse. Marie-Thérèse, in her immodest tranquility, is offering the deepest secrets of her body, a promise of pleasure. This conception of woman, flower or plant, and fertile earth, recalls the most ancient archetypes. Picasso uses it to feed his erotic fantasies. The sketchy, rapid brushstrokes, the superimposition of layers and the transparencies are all evidence of his frenzy.

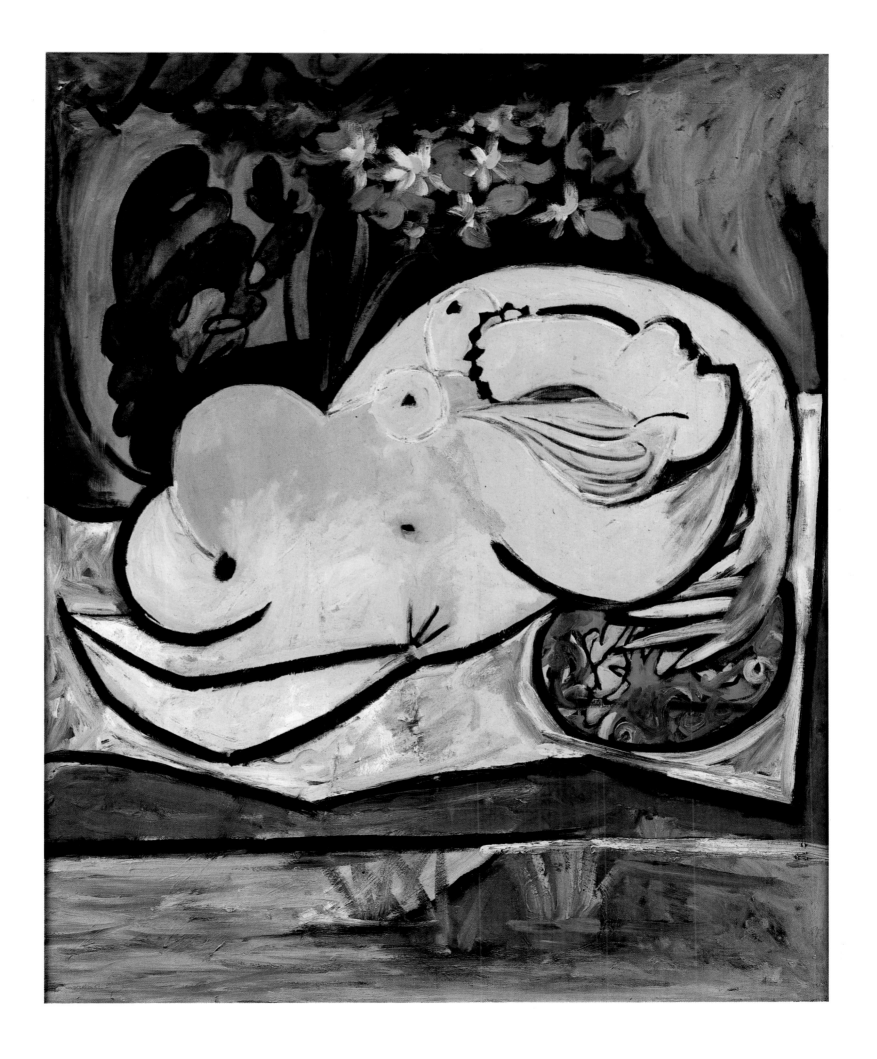

The Muse, *1935*

130 × 162 cm, Musée Nationale d'Art Moderne, Paris

The theme of the young girl drawing, a more general variation on the *Studio* theme and a transposition of the subject *Painter and his Model* begun in 1926, appeared for the first time in January 1933, in two separate drawings. The same motif resurfaced in 1935, but this time as a monstrous biomorphic face looking at itself in a mirror, which reflects a realistic image. The repetition of the actual model and her portrait was developed, in subsequent drawings, by the inclusion of a second young woman on her knees, bent over a table, sleeping. There are numerous preparatory studies for the final version of *The Muse*, which was completed in February 1935. A later drawing dated 11th February, with colour annotations, records its final state. There is a second version of this painting in New York in which the young girl is clothed and wears a coronet of flowers. The roundness of forms and the arabesques recall some of those works by Matisse inspired by Moroccan themes.

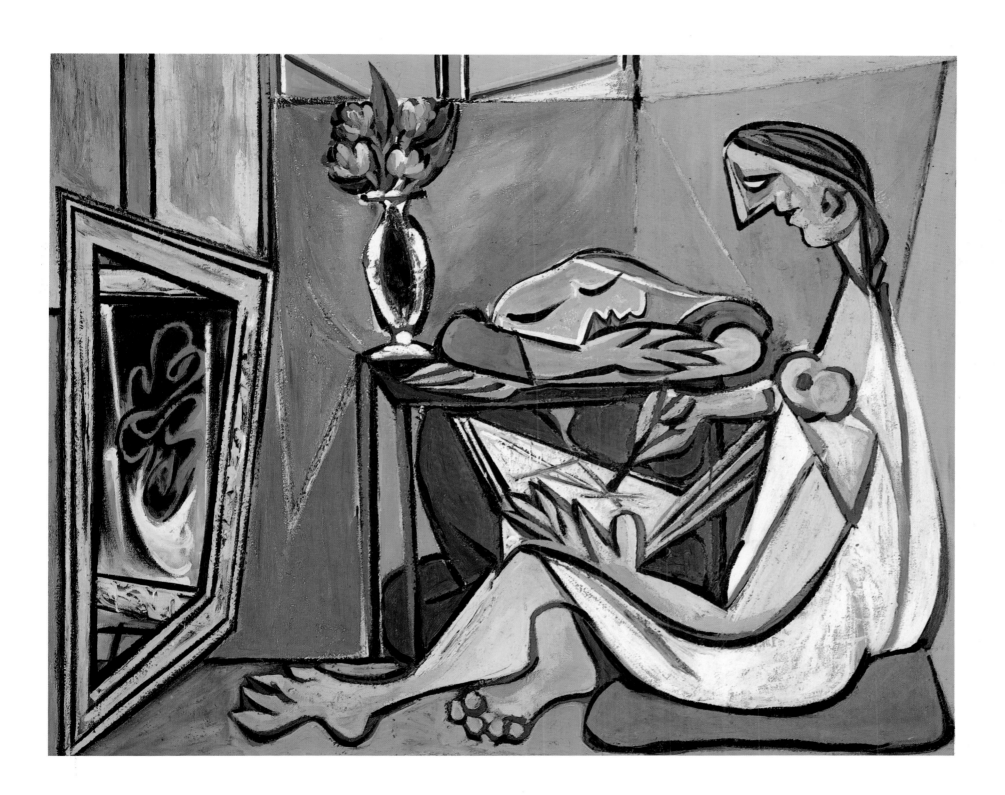

Minotaur and Dead Mare in front of a Cave, 1936

50 × 65.5 cm, Picasso Museum, Paris

A mythical and tragic element in Mediterranean culture, the Minotaur appears as one of the central themes in Picasso's universe. Half-man, half-beast, he is the incarnation of many disparate themes: monstrosity, primitive bestiality, the dark forces of the unconscious, executioner and victim, love and death. It is no coincidence that Picasso delivers Marie-Thérèse to the Minotaur, nor that it is she who is the blind Minotaur's guide. Picasso refuses to accept the usual symbolic value attached to the creature. His Minotaur is never consistently on the side of either good or evil

In this gouache, the Minotaur's almost human face, expressing such great sadness, is Picasso himself, and the eviscerated mare is Marie-Thérèse. The girl with the veil and crown of flowers symbolizes innocence and purity. She too is Marie-Thérèse. Picasso, then, was torn between love and duty. The hands reaching out from the cave could well belong to Olga.

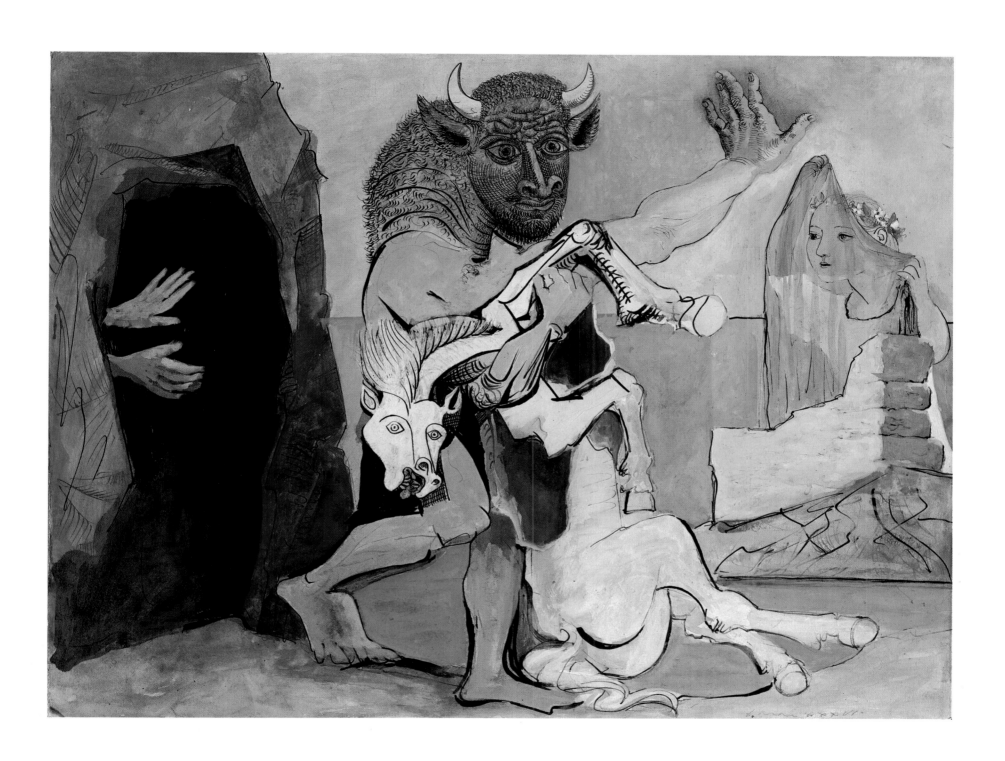

Portrait of Dora Maar, 1937

92 × 65 cm, Picasso Museum, Paris

Dora Maar, a photographer and painter, born of a Yugoslav father and French mother, grew up in Argentina. An independent 30 year old, she instantly seduced Picasso, who had finally made the break with Olga. Dora was the brunette to Marie-Thérèse's blond, and Picasso shared himself between them. His painting, like a diary, recounts his visits to Marie-Thérèse and Maïa, their daughter, and his visits to Dora Maar. Her long painted nails, her round, wilful chin, and her sparkling bright eyes figure amongst her many attributes. She is often represented in black and red, in bright colours and angular forms. During the war, the face of Dora Maar became the face of human suffering.

In this portrait, with its vivid colours, Dora glows. She is shown both full face and in profile, one red eye looking in one direction and one green eye in the other. These disortions give the painting its expressive effect and succeed in creating a striking likeness. By combining several means of expression Picasso reveals Dora Maar in her entirety, body and soul.

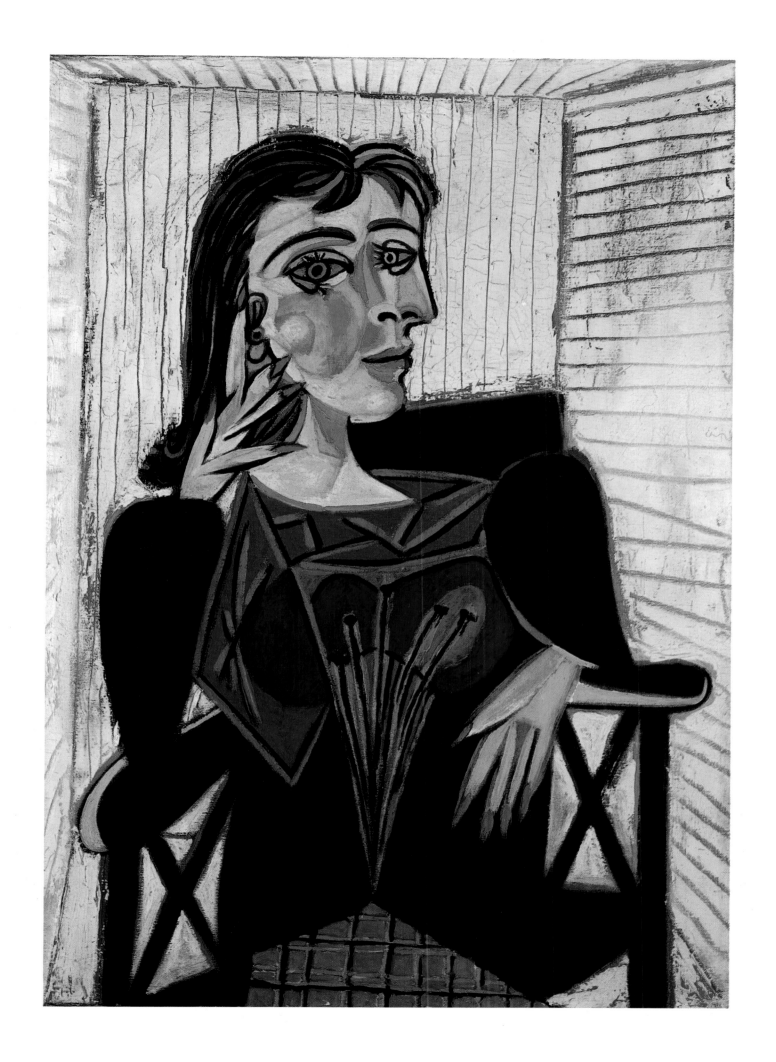

Large Bather with a Book, 1937

130 × 97.5 cm, Picasso Museum, Paris

A glimpse of blue sea behind the *Large Bather with a Book* indicates that she is on the beach, although this canvas does not date from a period when Picasso spent time by the sea. The location has been chosen to give scope to the three-dimensional volume of the figure. Space is unified and neutral, strictly confined to the dimensions of the painting. The fact that the bather almost totally occupies this space, adds to her monumentality. Picasso mixed oil and pastel in a thick paste which gives the body a rough, brittle appearance. The rounded volumes which define her seem in places, to be carved out of a sheer rock-face. The form of the book is also treated in an unusual fashion; it resembles a triangular block of stone and the writing on it takes the shape of a thumb-print.

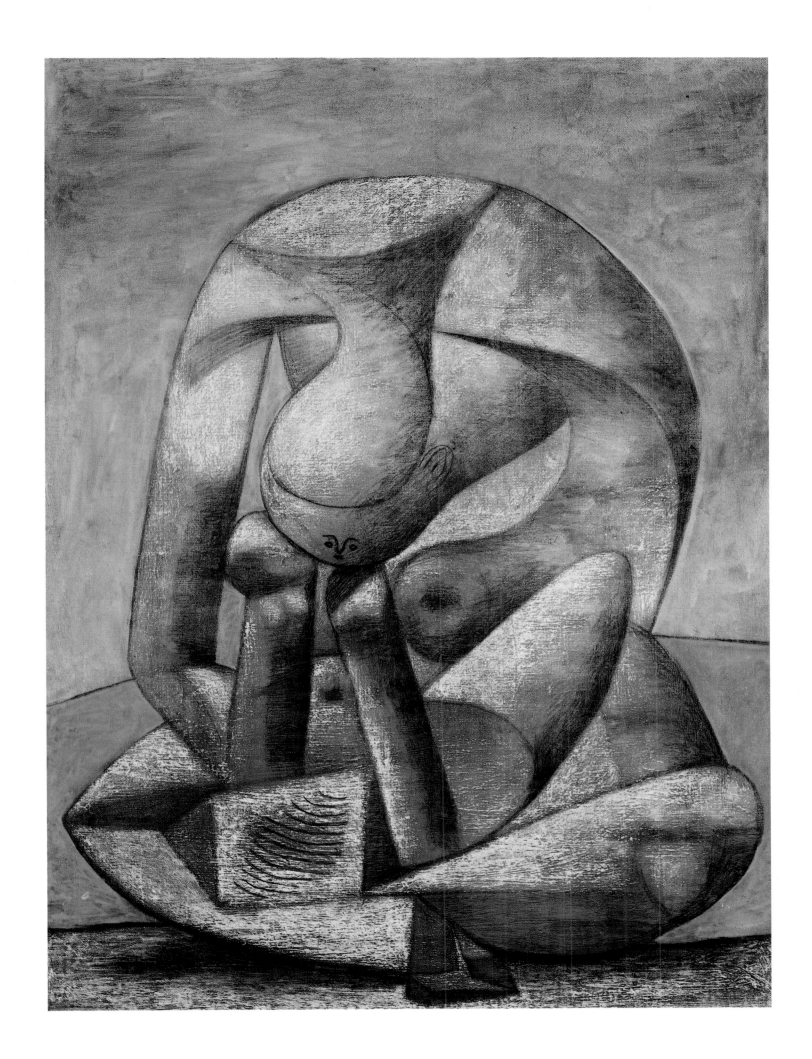

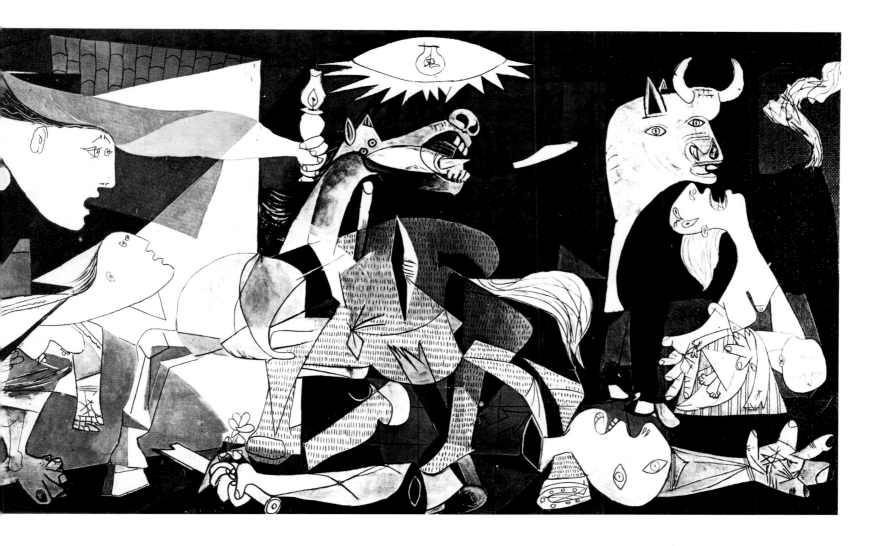

Guernica, 1937

349.3 × 776.6 cm, Museum of Modern Art, New York

The bombardment of this small Spanish town produced an equally explosive reaction in Picasso. He immediately began work on preliminary drawings and sketches, outlining the principal elements of the work: the impassive bull, the agonized horse, the warrior laid out on the ground, the lamp-bearer. On 11th May Picasso began to work on canvas, tentatively at first, and completed seven versions which were photographed by Dora Maar. It is fortunate that the genesis of this exceptional and universal work was recorded for posterity.

Guernica was painted in black and white. The principal lines of energy form a triangle. At the centre a wounded soldier, pierced by a spear, is crushed under a horse dying in agony. The left of the painting is dominated by an immovable bull, whose artistic and mythical origins date back to Minoan culture. He symbolizes power. Three women form a tragic chorus: one on the left is falling into a house on fire, a second is running away and a third, a mother, is screaming with her dead child in her arms.

Guernica is an enormous scream. All the heads are yelling into the void. In all Picasso's paintings which take war as their theme, right up to *The Rape of The Sabine Women*, the subject is the Massacre of the Innocents.

Weeping Woman, 1937

54 × 44.5 cm, Tate Gallery, London

War continued to haunt Picasso's painting. The echo of Guernica reverberated through his work and found its focus in the weeping woman, which he reproduced many times using different techniques: drawing, etching and sculpture. She is a symbol of the despairing Spanish women during the Civil War. In this series, which obsessed Picasso in the autumn of 1937, he dealt with the horrors of war at its most banal, the very reverse of the epic. Dora Maar was his model. 'I never saw her in tears, nor could I have imagined her like that', he said later. Seldom has painting expressed grief with such power. The brush-strokes are wrenched onto the canvas by violent colour, the face is completely distorted. The black handkerchief clutched in a pathetic gesture stifles a cry of suffering never to be heard. The paroxysm of grief that this image projects is timeless.

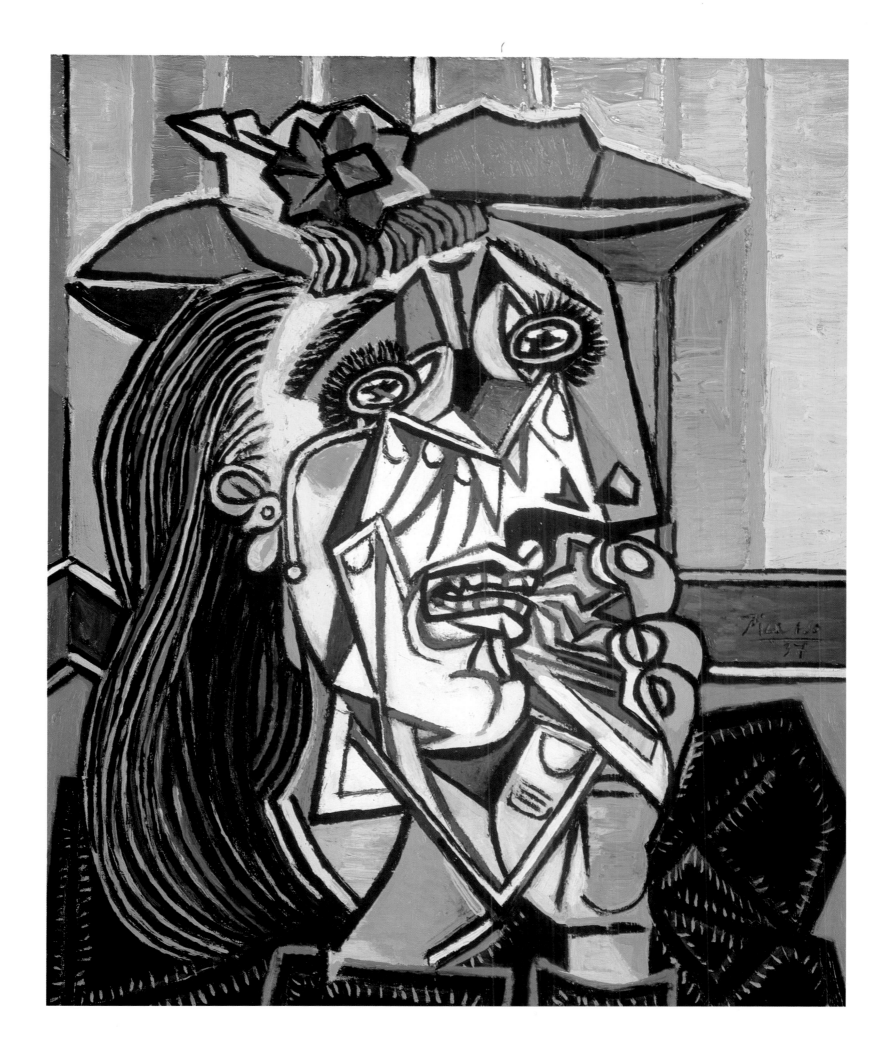

Aubade, 1942

195 × 265 cm, Musée Nationale d'Art Moderne, Paris

Acknowledged to be the key work of the period of German Occupation, *Aubade* is, in fact, a variation on the traditional serenade theme. The subject matter also represents the theme of watchman and sleeper to which Picasso constantly referred. The composition is inspired by Titien's *Venus Listening to Music*. The theme of two women in an interior also evokes *Odalisque as a Slave*. But here the atmosphere of the harem has disappeared. The horror of war and the claustrophobia of the curfew demand an atmosphere of incarceration and cruelty. The two women are imprisoned in a closed and sterile room. The dark colours, the blacks, greys and browns are lit by strident violet and green. The angular, sharply defined forms of the female guard with the mandoline, the broken slats of the bed and the corpse-like position of the nude combine to create a sense of tightly strung tension. The empty canvas in the bottom left-hand corner indicates the impossibility of painting an image, and the bird, drawn in profile, in the stomach of the seated woman, represents the hope for freedom which exists in all of us.

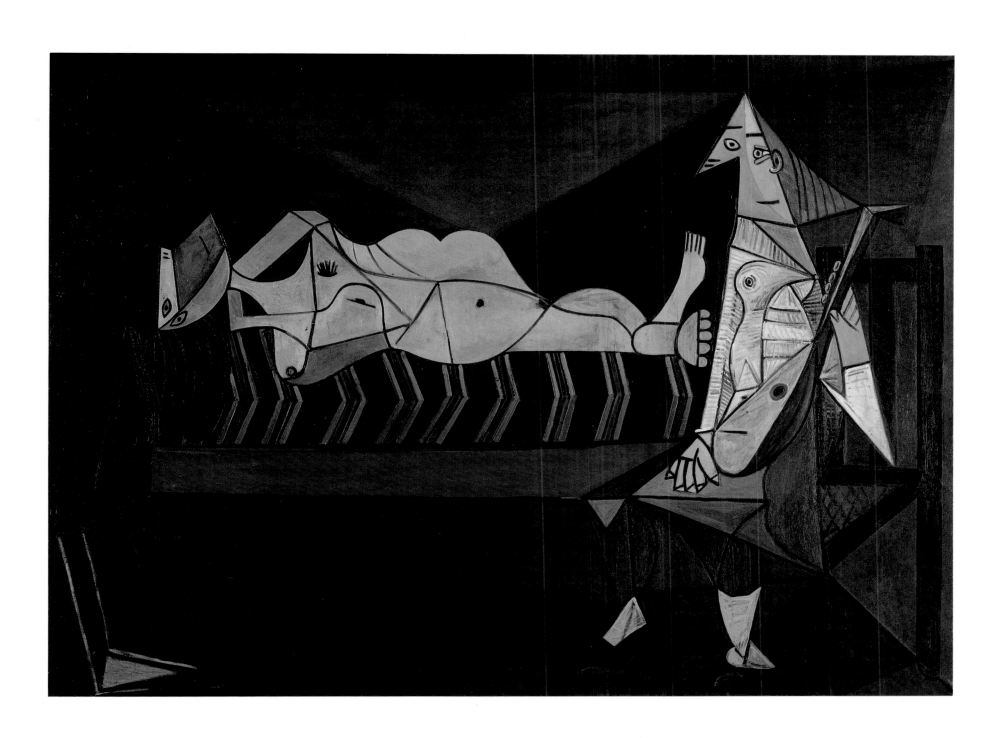

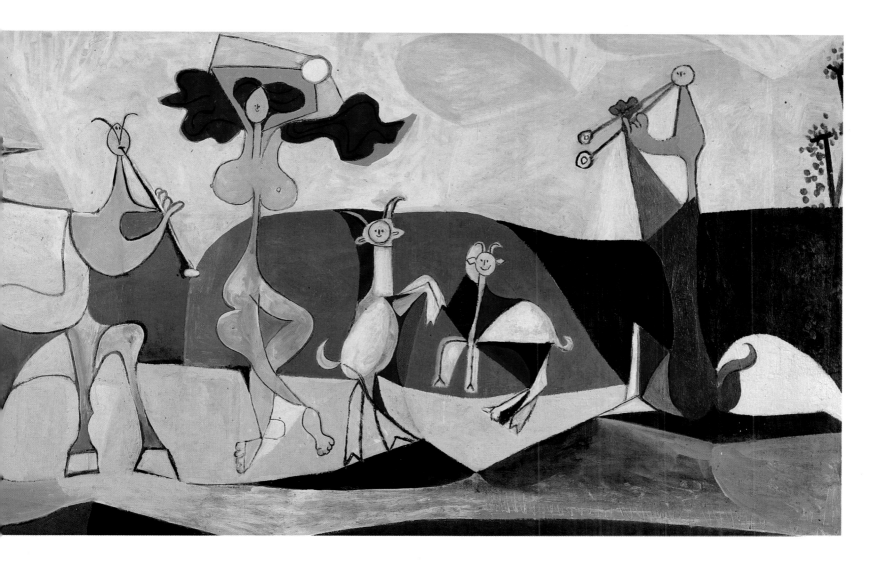

Joie de Vivre, *1946*

120 × 250 cm, Picasso Museum, Antibes

Unusually, Picasso gave this painting a second title which he wrote on the back of the canvas: *Antipolis*, meaning 'the town opposite', the town first seen by sailors arriving by sea. This second title, which is less well-known than *Joie de vivre*, may be a more apt description for the sense of antiquity rediscovered, of sunshine and of the pleasure taken in life and in painting, which are all expressed in the canvas. The pyramidal construction centred on the dancer's tambourine, the only completely white space in the painting, is extremely classical. The bright, happy blues, yellows and white reflect the humour of the moment. 'It is strange that in Paris I never draw fauns, centaurs or mythological heroes like this. You would think that they only exist here.' Once again, the painter's life is evident in his painting. Picasso, Sima and Gilot have become the faun, the nymph and the centaur, the two children are represented by the young goats.

Sixteen studies were made in preparation for this canvas, the major work in the Antibes collection. They show how the arrangement of the central figures and their features developed. The background exists only in the final work.

Jacqueline with Flowers, 1954

100 × 81 cm, Jacqueline Picasso collection, Mougins

A continual source of inspiration for Picasso, Jacqueline never really posed for her husband. Even so, she was painted more frequently than any of his other companions, and her opinion meant a great deal to him. There are hundreds of portraits of her in existence, standing, sitting, reclining, nude, dressed in Turkish costume. In this celebrated portrait in lively, joyful colours, one of the earliest in the series, Picasso perfectly captures Jacqueline's clean profile and long neck. The simplification of the body, the elongation of the neck and the geometric treatment of the hair reflect her own particular posture which fascinated Picasso. He successfully evokes her dignified charm and openness of expression. The roses are coming gently into flower like a token of love. On the same day, in June 1954, Picasso painted two other magnificent portraits of Jacqueline whom he called *Madame Z*. In one she is represented with hands crossed, in the other with legs folded.

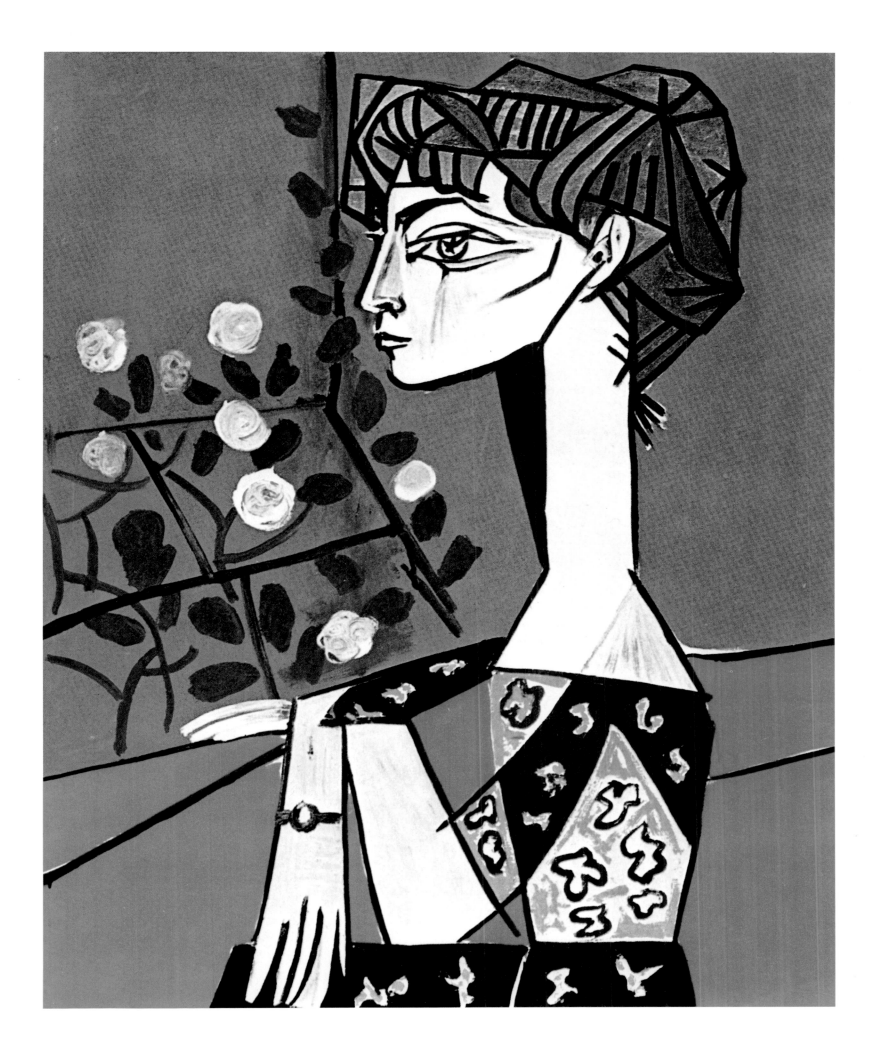

'La Californie' Studio, 1956

114 × 146 cm, Picasso Museum, Paris

In 1955, Picasso moved to Cannes, where he took over a splendid turn-of-the-century building surrounded by a huge, luxuriant garden. The villa was called 'La Californie'. He transformed the enormous living-room into a studio, and further established his ownership of the space by representing it in his paintings. Between October 1955 and November 1956, Picasso completed fifteen of these *Studios* which he referred to as 'interior landscapes'.

The interior of the villa is, indeed, easily recognizable. We notice, in particular, a portrait of Jacqueline in Turkish dress. As in the famous *Studio* by Courbet, the central space is occupied by a blank canvas. It is possible to see Picasso's use of the studio theme as a belated tribute to Matisse, whose own works on the same subject date from 1911 to 1913. This, however, was to be the final word in a continual conversation between the two painters. Matisse died two years later.

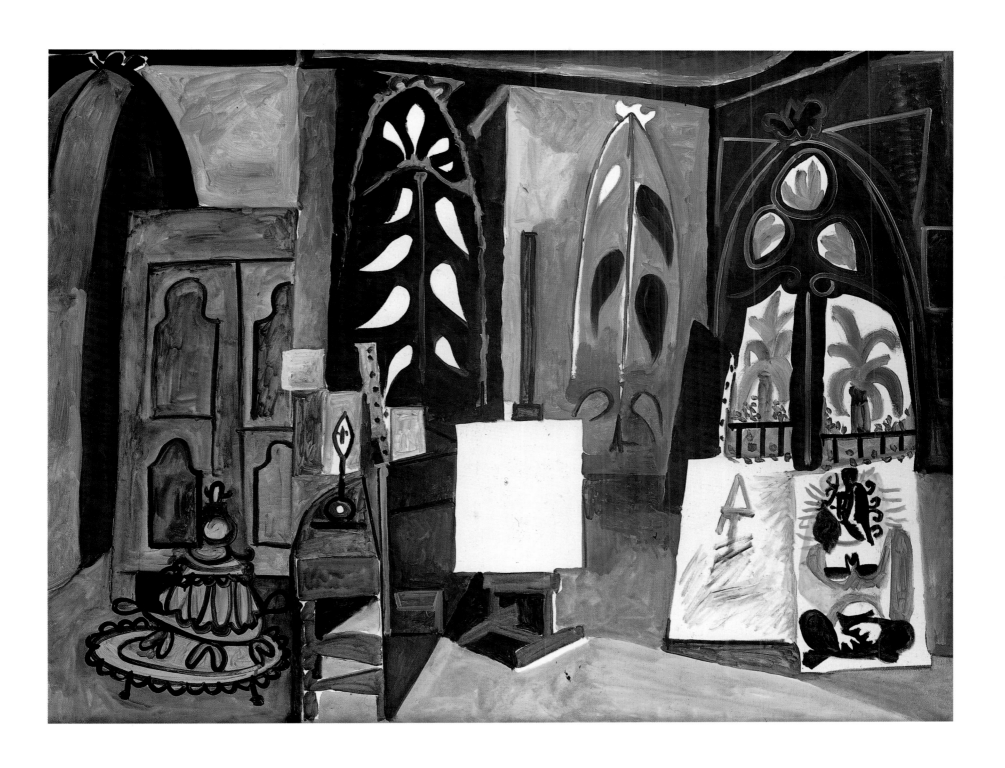

Las Meninas (after Velázquez), 1957

162 × 130 cm, Picasso Museum, Barcelona

Between 17th August and 30th December 1957, shut away in his studio at 'La Californie', Picasso completed fifty-eight paintings, forty-four of which were *Meninas*. As he went deeper and deeper into the work, he gradually confronted every aspect of realist representation evident in the Velázquez painting. Picasso soon began to concentrate on the Infanta, making her his principal character. Treated in simplified forms and flat surfaces of colour, she is the central visual point around which the composition is organized. The intense yellow of her dress recalls the subtle play of light on the Infanta's robe in the painting by Velázquez. The construction of space by means of blocks of uniform colour is reminiscent of Matisse.

Les Meninas represents the beginnings of Picasso's return to Spain. After 1958, he was to complete a whole series of paintings and drawings dealing with bulls and bull-fighting. Later, at Vauvenargues, he painted a series of still lifes which must be seen as his most Spanish work, along with the gentlemen of the Golden Age from the Avignon period.

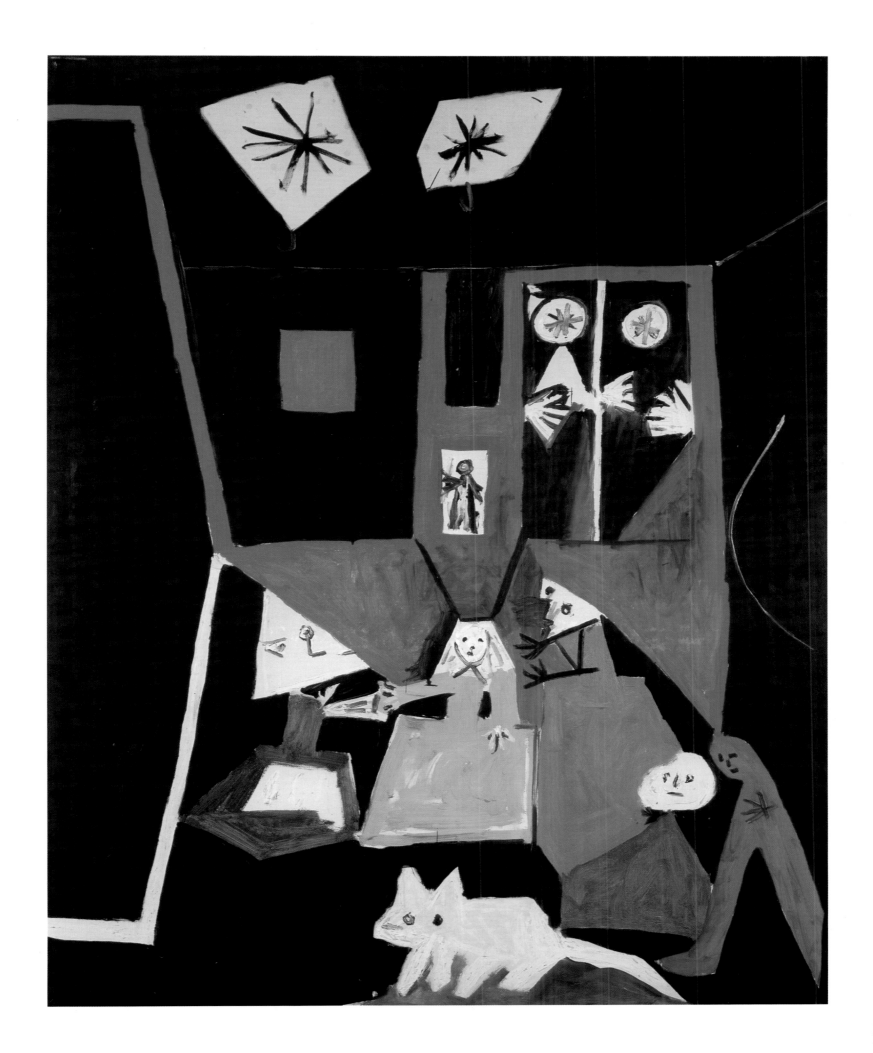

Le Déjeuner sur l'herbe (after Manet), 1961

130 × 97 cm, Museum of Modern Art, Louisiana

Begun in August 1959, and not completed until July 1962, the *Déjeuner sur l'herbe* series is Picasso's last interpretation of earlier masters. It is also the most rich and the most extensive in terms of the time he spent on it and the multiplicity of solutions he discovered, taking the original model as his starting point. Twenty-seven paintings, a hundred and forty drawings, three lino-cuts and a dozen cardboard maquettes for sculptures. In these exercises in style Picasso was putting his own pictorial language to the test. By successfully developing the original work without overthinking the fundamental structure, he adapted his own formal style to the situation, applying his own theories and discoveries about painting to see if they would work here too. The treatment of the colours reveals his enthusiasm. The green, white and black tonalities are an evocation of night. A cold, naked light emanates from the moon. The bather is the key element around which the rest of the space is organized.

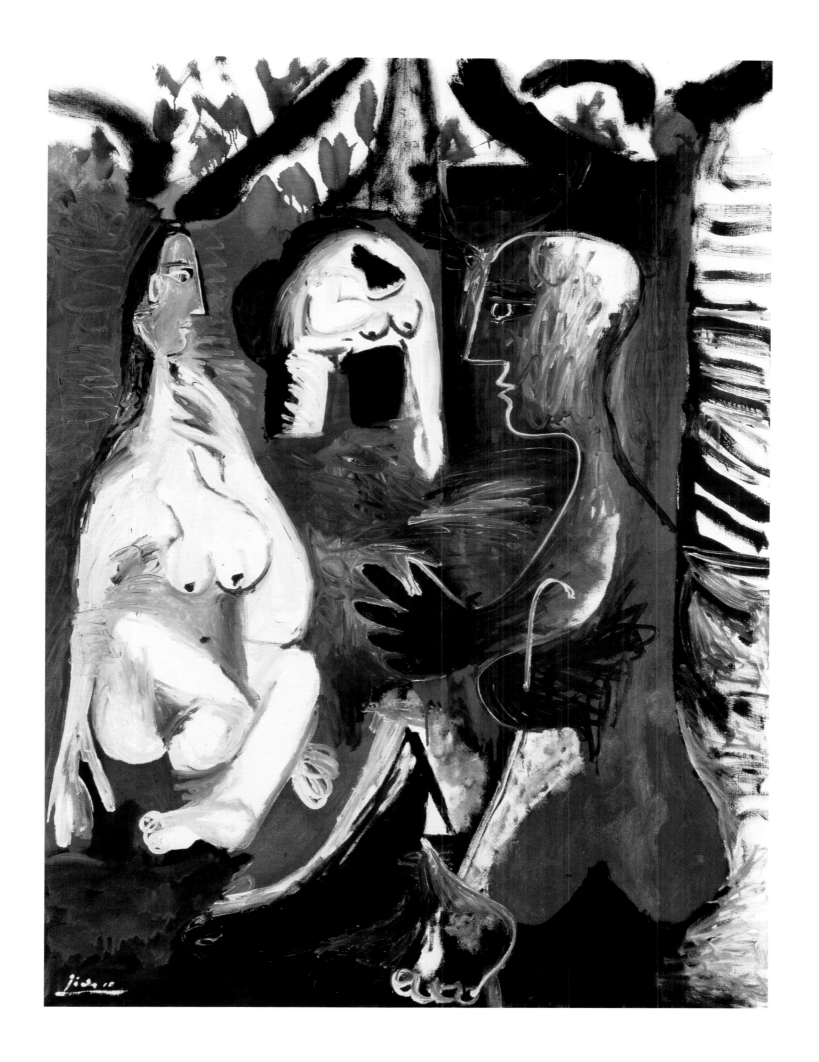

The Kiss, 1969

97 × 130 cm, Gilbert de Botton collection, Switzerland

Almost half a century had gone by since *The Kiss* of Juan-les-Pins in 1925, but the ardour of Picasso's desire is still evident. 'Art is never chaste', he insisted. The crude realism of *Kisses* reaches its climax in the *Embrace* series. Never has erotic potency been so vividly suggested. In some of these canvases, the couple becomes a kind of beast with two heads in which it is impossible to distinguish the man from the woman. More than ever, Picasso seems to be affirming the importance of physical passion in his life. Whether this painting represents a simple statement or the obsession of an old man, it is impossible to say. It is surely significant that Picasso's last two themes were love and painting, for it was these that represented the meaning of life for him.

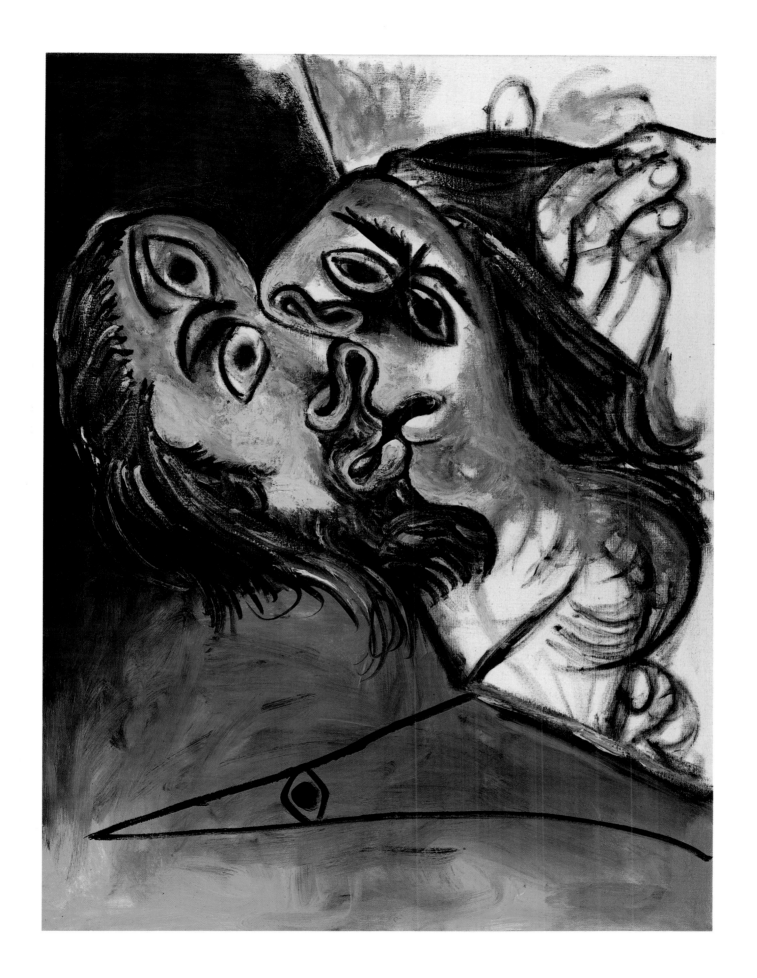

Rembrandtesque Character and Love, 1969

162 × 130 cm, Rosengart Foundation, Lucerne

'Painting is still to be done,' said Picasso towards the end of his life, as if he had to start all over again. In fact, having threatened the Renaissance heritage with the Cubist revolution, Picasso had restored new fields of investigation to painting. For a man who questioned everything, his own painting in particular, it is only natural that, at the end of his life, a final, agonized uncertainty should arise about the nature of painting and how to paint. His Rembrandtesque character appeared, between 1969 and 1970, in a kaleidoscope of forms, signs in an explosion of hastily scribbled colours or thick hatching with incoherent broad strokes and flat surfaces.

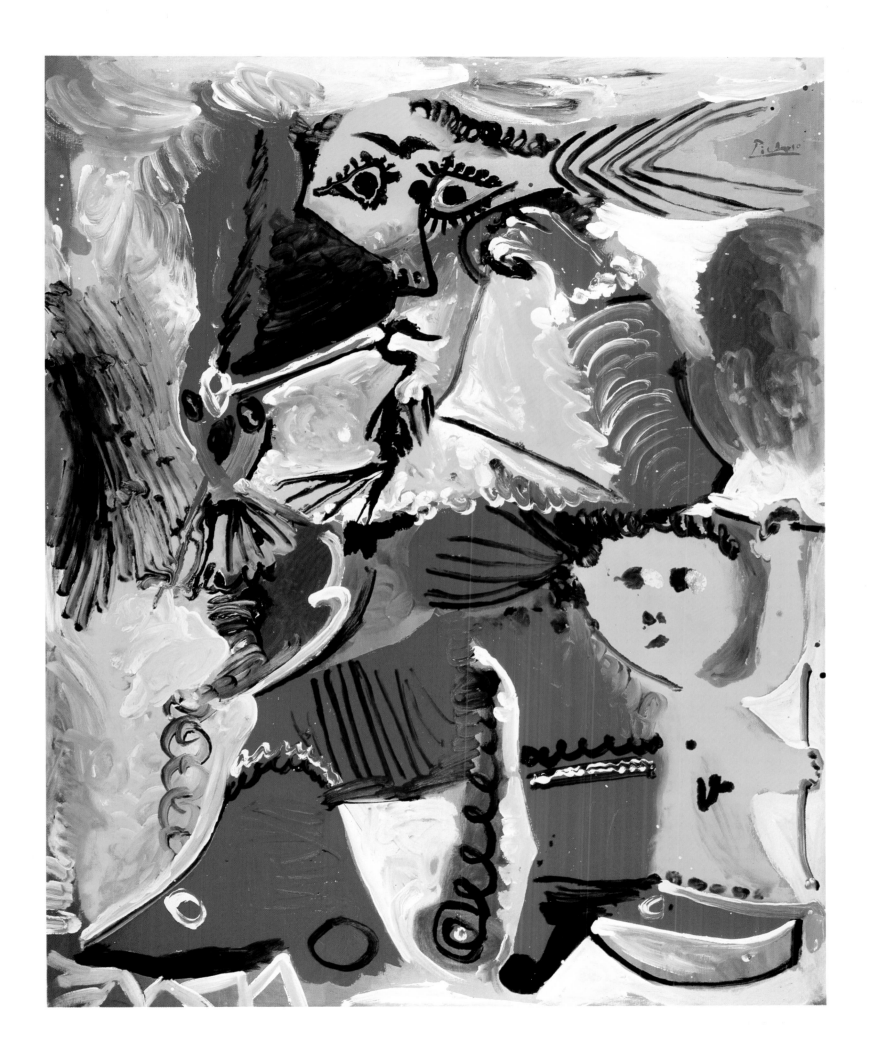

Reclining Nude and Guitar Player, 1970

130 × 195 cm, Picasso Museum, Paris

Towards the end of Picasso's life, we find in the subjects, style and atmosphere of his painting, a Spanish resonance. Matadors, swordsmen, guitarists and water-melon eaters make up the final pictorial universe. The humour, derision and tragic sense of death which pervade his last canvases are also Hispanic in nature. Black and grey harmonies predominate, enlivened by reds and pinks, golden yellow and orange.

Here, Picasso returns to the serenade theme we have seen in *Aubade*. It is the music of love. The woman is naked and at peace with the world. The guitar is an extension of her body in a playful confusion of forms and colours. The schematic forms are crudely outlined. The specific form of the heads recalls the earlier profiles done at Boisgeloup.

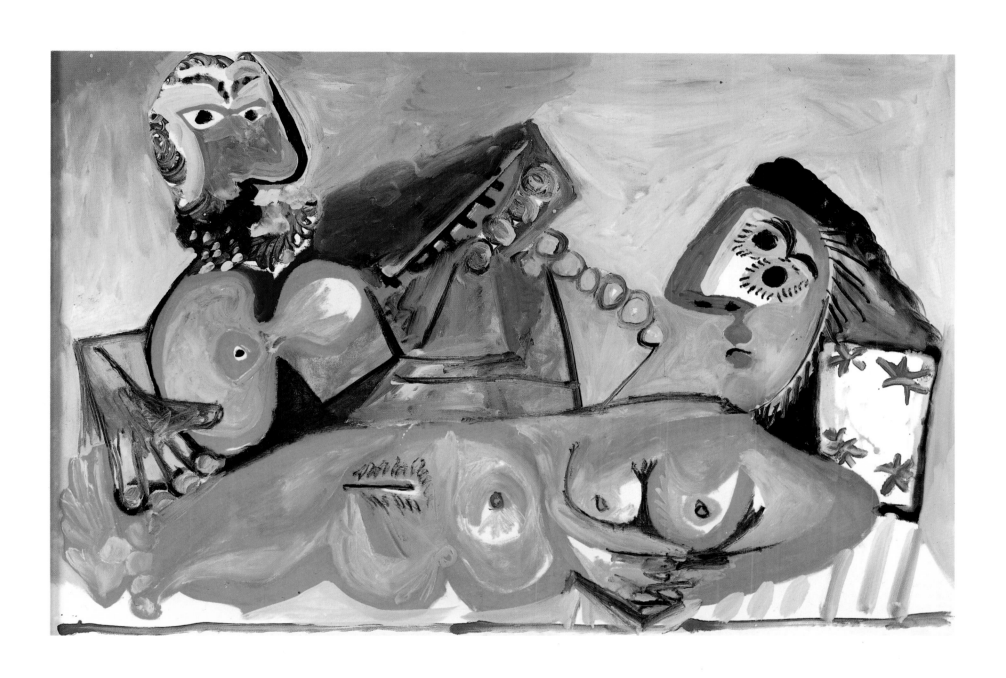

Landscape, 1972

130 × 162 cm, Picasso Museum, Paris

Picasso painted few landscapes. His subject for reflection was not nature but environment, spectacle and, above all, forms. When he represents nature, it is domesticated nature. He outlines her in black and subjugates her exuberance, as we see in this *Landscape* done at Mougins. Only the shape of the palm-trees and the hill side are recognizable. The other motifs are difficult to identify. Everything is in the treatment; the thick streaks of dripping paint, the brush-marks, the transparency of superimposed layers. Dots, black and white spots, and zig-zag lines are interwoven to suggest the lines of force which give the composition its structure. The greenish tone of the whole gives it a dramatic effect and there is, in this landscape painted when Picasso was 91 years old, an almost original power. At the end of his life, the artist who had been able at the age of 12 to paint like Raphael, had rediscovered the spontaneity and freshness of childhood.

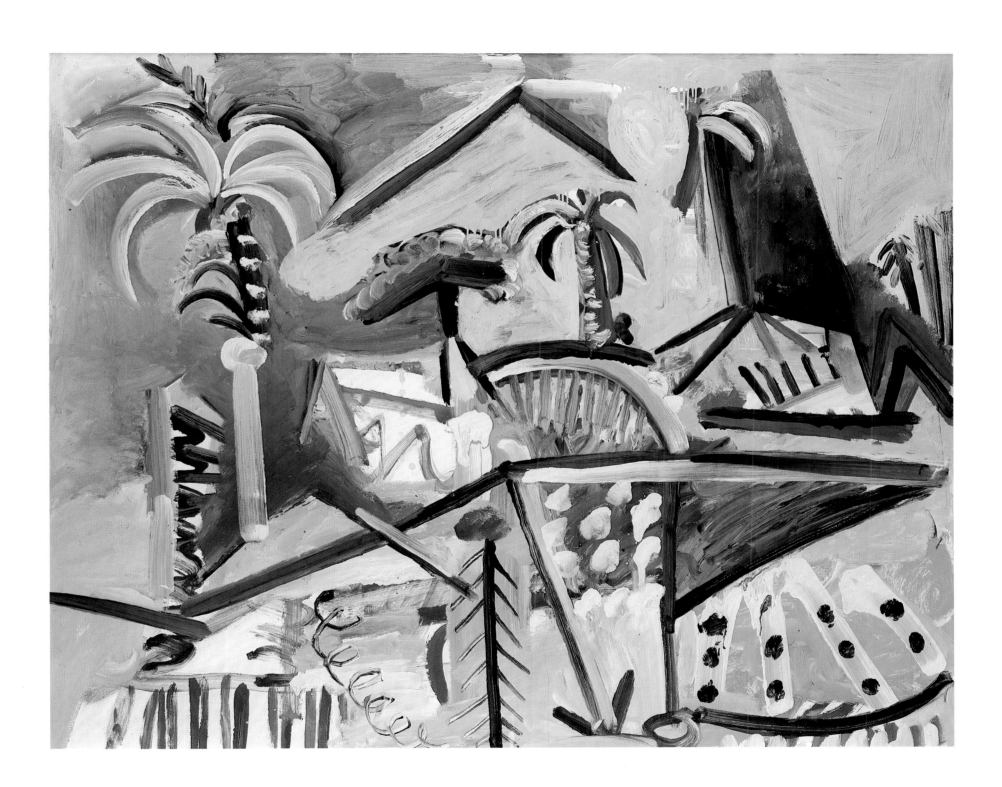

SELECTED BIBLIOGRAPHY

BRASSAÏ, G.H., *Conversations avec Picasso*, Paris, Gallimard, 1964.

CABANNE, Pierre, *Picasso's Century*, Paris, Denoël, 1975.

DAIX, Pierre, *Life of the Painter*, Paris, Le Seuil, 1977.

BOUDAILLE, Georges, and ROSSELET, Jean, *Picasso, 1900–1096, Catalogue raisonné*, Neuchâtel, Ides et Calendes, 1979.

DUNCAN, David, *Picasso's Little World*, Paris, Hachette, 1959.

—— *Picasso's Picassos*, Lausanne, Edita, 1961.

FERMIGIER, André, *Picasso*, Paris, Livre de Poche, 1969.

GILOT, Françoise, and LAKE, Carlton, *Life with Picasso*, London and New York, Thomas Nelson and McGraw Hill, 1964.

KAHNWEILER, Daniel-Henry, *Confessions esthétiques*, Paris, Gallimard, 1963.

LEYMARIE, Jean, *Picasso. Métamorphoses et Unité*, Geneva, Skira, 1971.

OLIVIER, Fernande, *Picasso and his Friends*, London, Heinemann, 1964.

PARMELIN, Hélène, *Picasso dit . . .*, Paris, Gonthier, 1966.

PENROSE, Roland, *Picasso*, Paris, Flammarion, 1982.

STEIN, Gertrude, *Picasso*, Paris, Christian Bourgois, 1978.

ZERVOS, Christian, *Pablo Picasso*, Paris, Cahiers d'Art, 1932–1978, vol.33.

CHRONOLOGY

1881
25th October: Picasso born in Málaga, Spain, first child of the Ruiz Picasso family.

1888 or 1889
Picador, earliest extant Picasso painting.

1891
September, La Coruña.

1892
October, Picasso enters the drawing and design class at the Fine Arts school in La Coruña.

1894
Picasso writes and designs his own newspapers: *La Coruña* and *Azul y Blanco*. First portraits of his family.

1895
Don José appointed professor at La Lonja in Barcelona. Summer: Madrid, first visit to the Prado. Vacation in Málaga. Return by sea to Barcelona. September-October: Picasso passes La Lonja entrance exam. Winter: *First Communion*.

1896
Science and Charity. Summer: Picasso moves into his own studio.

1897
12th June: opening of *Els Quatre Gats*. September: leaves for Madrid. October: wins admission prize at the San Fernando Academy. *Science and Charity*, mention of honour at the Fine Arts exhbition for Madrid, gold medal in the Màlaga exhibition.

1898
Returns to Barcelona then leaves for Horta, Pallarès' home town.

1899
February: return to Barcelona. Enters the *Els Quatre Gats* milieu. Meets Casagemas and Sabartés.

1900
Picasso moves into the calle Riera de San Juan. 1st February: exhibition at *Els Quatre Gats*. October: leaves for Paris with Casagemas. 20th December: returns to Barcelona.

1901
Mid-January: leaves for Madrid. 17th February: Casagemas' suicide in Paris. End of April: return to Barcelona. May: leaves for Paris. 24th June: exhibition opening at the Vollard Gallery. Meets the poet Max Jacob. Winter: first blue portrait.

1902
End of January: Barcelona. October: return to Paris. Shared hard times with Max Jacob. 15th November: exhibition at the Berthe Weil gallery.

1903
January: Barcelona. Spring: begins work on *La Vie*.

1904
April: Paris, moves into the Bateau-Lavoir. Autumn: *Maternités Roses*. Meets Guillaume Apollinaire and André Salmon. Also meets Fernande Olivier. Last exhibition at the Berthe Weil gallery.

1905
26th February: exhibition at the Serrurier gallery. Spring: works on *Saltimbanques*. Summer: trip to Holland. Autumn: meets Gertrude and Leo Stein.

1906
Winter: Picasso begins his portrait of Gertrude Stein. Meets Matisse. March: Vollard buys most of the pink canvases. May: Barcelona, then Gosol. *Two Brothers*.

1907
January–July: *Les Demoiselles d'Avignon*. Summer: visits the Trocadéro Museum. Discovers Negro art.

1908
End of September: meets Braque.

1909
May: Barcelona, then Horta de Ebro. September: moves to 11, boulevard de Clichy.

1910

June–September: Barcelona, then Cadaqués where he is joined by Derain. September: portait of Kahnweiler.

1911

April: first American exhibition at the Photo Secession Gallery. Summer: Céret with Braque. Autumn: Eva ('ma jolie') enters Picasso's life.

1912

Still Life with Cane Chair, first collage. June–October: Sorgues. October: moves to 242, boulevard Raspail. December: contract with Kahnweiler.

1913

Summer in Céret. September: moves to the rue Schoelcher.

1914

Winter: third period of pasted paper collages. June–October: Avignon. Autumn: *cubisme froid*.

1915

14th December: death of Eva.

1916

May: Cocteau introduces Diaghilev to Picasso. A project for *Parade*.

1917

January: Barcelona, February–April: Rome with Cocteau. Meets Stravinsky and Olga. 18th May: première of *Parade* at Chatelet. November: Picasso and Olga set up home together.

1918

23rd January: Matisse–Picasso exhibition at Paul Guillaume's gallery. 12th July: marries Olga. 9th November: death of Apollinaire.

1919

May: London. Picasso works on the ballet *Le Tricorne* with music by Manuel de Falla. Summer: Saint-Raphaël.

1920

January: refuses to participate in the Salon des Indépendants. Summer: Juan-les-Pins. *Three Bathers*.

1921

4th February: birth of Paulo. Summer: Fontainebleau. *Three Musicians*.

1922

June–September: Dinard. Décor for *Antigone* by Cocteau.

1923

June–September: Cap d'Antibes. *The Flute of Pan*.

1924

18th June: première of Satie's *Mercure*. 20th June: première of *Train Bleu*, music by Darius Milhaud. The Surrealists align themselves with Picasso. Summer: Juan-les-Pins.

1925

March–April: Monte-Carlo. June: *The Dance*. July: Juan-les-Pins.

14th November: takes part in the first Surrealist exhibition.

1926

Spring: *Guitars* with nails. Summer: Juan-les-Pins. October: Barcelona.

1927

January: meets Marie-Thérèse Walter. Summer: Cannes. Album of drawings for *Métamorphoses*.

1928

Beginning of the year: *Painter and Model*. Summer: Dinard. *Bathers*. Autumn: metal sculptures with Julio Gonzalez.

1929

Summer: last vacation at Dinard.

1930

February: *The Crucifixion*. June: buys the Boisgeloup château. Summer: Juan-les-Pins.

1931

May: Boisgeloup. Summer: Juan-les-Pins. Two major books published: *Métamorphoses* by Ovid (Lausanne, Skira) and *Le Chef-d'œuvre inconnu* by Balzac (Paris, Ambroise Vollard).

1932

January: *The Dream*. June: retrospective at the Georges Petit gallery, then at the Kunstaus in Zurich. Summer: Boisgeloup.

1933

Spring: *The Sculptor's Studio*. Summer: Cannes. Mid-August: Barcelona.

1934

July: bullfight canvases. End of August: trip to Spain. September: *Blind Minotaur Guided by a Young Girl*.

1935

June: separation from Olga. Summer: Boisgeloup. 5th October: birth of Maïa, daughter of Marie-Thérèse.

1936

March: Juan-les-Pins with Marie-Thérèse. August: Mougins with Dora Maar. Autumn: Picasso obliged to leave Boisgeloup. He works in the Tremblay-sur-Mauldre studio lent to him by Vollard.

1937

26th April: Guernica bombed. Mid-June: *Guernica* completed. October–December: *Weeping Women*.

1938

July: Mougins with Dora Maar.

1939

13th January: death of Picasso's mother. July: Antibes at Man Ray's house with Dora Maar. September: Royan.

1940

Beginning of the year at Royan. Autumn: Picasso moves into the Grands Augustins.

1941
January: begins writing *Desire Caught by the Tail*.
1942
May: *Aubade*.
1943
February–March: *Man with Sheep*. May: meets Françoise Gilot.
1944
19th March: private performance of *Desire Caught by the Tail*. 5th October: Picasso joins the Communist Party.
1945
April–May: *The Charnel House*. July: Cap d'Antibes with Dora Maar. 26th November: Françoise Gilot returns to Picasso's house.
1946
Mid-March: Picasso joins Françoise in Golf Juan. Visits Matisse in Nice. October: begins work in the Château d'Antibes.
1947
15th May: birth of Claude. June: Golf Juan. August: beginning of ceramic work.
1948
25th August: Picasso attends the Congress of Intellectuals for Peace in Wrocław. Mid-September: Vallauris.
1949
9th January: *Dove* lithograph. 19th April: birth of Paloma. 20th April: opening of the Peace Congress in the Salle Pleyel. Spring: Vallauris, buys the Fournas studios. Autumn: sculptures.
1950
March: *The Goat*. 6th August: inauguration of *Man with Sheep* at Vallauris by Laurent Casanova.
1951
15th January: *Massacre in Korea*.
1952
End of April: drawings for *War and Peace* for the decoration of the Vallauris chapel.
1953
September: Françoise Gilot leaves for Paris with the children.
1954
April: portrait of Sylvette David. June: meets Jacqueline Roque. December: begins variations on *Women of Algiers*.
1955
May: moves into 'La Californie' villa in Cannes. June: retrospective in the Museum of Decorative Arts.
1956
March: *'La Californie' Studio*.
1957
April: retrospective organized by Alfred Barr at the Museum of Modern Art in New York. 17th August: begins work on *Las Meninas*.

1958
29th March: presentation of decoration for UNESCO: *The Fall of Icarus*. September: Picasso buys the Vauvenargues château.
1959
10th August: first drawings for *Le Déjeuner sur l'herbe* after Manet.
1961
2nd March: marries Jacqueline at Vallauris. June: moves into Notre-Dame-de-Vie at Mougins. October: Picasso's eightieth birthday party at Vallauris.
1962
November: *The Rape of the Sabine Women*.
1964
April: publication of *Life with Picasso* by Françoise Gilot and Carlton Lake.
1966
19th November: retrospective in the Grand Palais and the Petit Palais in Paris.
1967
Forced to leave the Grands Augustins studio.
1970
January: donation of works owned by the family to Picasso Museum in Barcelona. May–October: exhibition at the Palais des Papes in Avignon.
1971
April: exhibition at the Louise Leiris gallery.
1972
30th June: last self-portrait.
1973
January: exhibition at the Louise Leiris gallery. 8th April: death of Picasso. May–September: exhibition of 201 paintings at the Palais des Papes in Avignon.

LIST OF PLATES

89: *The Flute of Pan*, 1923, oil on canvas, 205 × 174 cm. Picasso Museum, Paris.

91: *Harlequin (Portrait of the painter, Jacinto Salvado)*, 1923, oil on canvas, 130 × 97 cm. Musée National d'Art Moderne, Paris.

93: *Paulo as Harlequin*, 1924, oil on canvas, 130 × 97.5 cm. Picasso Museum, Paris.

95: *The Dance*, 1925, oil on canvas, 215 × 142 cm. Tate Gallery, London.

97: *Painter and Model*, 1926, oil on canvas, 172 × 256 cm., Picasso Museum, Paris.

99: *Woman in an Armchair*, 1929, oil on canvas, 195 × 129 cm. Picasso Museum, Paris.

101: *The Crucifixion*, 1930, oil on plywood, 51.5 × 66.5 cm. Picasso Museum, Paris.

103: *The Dream*, 1932, oil on canvas, 130 × 97 cm. Mr. and Mrs. Victor W. Ganz collection, New York.

105: *Bullfight*, 1933, oil on wood, 31 × 40 cm. Picasso Museum, Paris.

107: *Nude in a Garden*, 1934, oil on canvas, 162 × 130 cm. Picasso Museum, Paris.

109: *The Muse*, 1935, oil on canvas, 130 × 162 cm. Musée National d'Art Moderne, Paris.

111: *Minotaur and Dead Mare in front of a Cave*, 1936, gouache and India ink, 50 × 65.5 cm. Picasso Museum, Paris.

113: *Portrait of Dora Maar*, 1937, oil on canvas, 92 × 65 cm. Picasso Museum, Paris.

115: *Large Bather with a Book*, 1937, oil, pastel and charcoal on canvas, 130 × 97.5 cm. Picasso Museum, Paris.

117: *Guernica*, 1937, oil on canvas, 349.3 × 776.6 cm. Museum of Modern Art, New York.

119: *Weeping Woman*, 1937, oil on canvas, 54 × 44.5 cm. London, Tate Gallery.

121: *Aubade*, 1942, oil on canvas, 195 × 265 cm. Musée National d'Art Moderne, Paris.

123: *Joie de Vivre*, 1946, oil on fibreboard, 120 × 250 cm. Picasso Museum, Antibes.

125: *Jacqueline with Flowers*, 1954, oil on canvas, 100 × 81 cm. Jacqueline Picasso collection, Mougins.

127: *'La Californie' Studio*, 1956, oil on canvas, 114 × 146 cm. Picasso Museum, Paris.

129: *Las Meninas (after Velázquez)*, 1957, oil on canvas, 162 × 130 cm. Picasso Museum, Barcelona.

131: *Le Déjeuner sur l'herbe (after Manet)*, 1961, oil on canvas, 130 × 97 cm. Museum of Modern Art, Louisiana.

133: *The Kiss*, 1969, oil on canvas, 97 × 130 cm. Gilbert de Botton collection, Switzerland.

135: *Rembrandtesque Character and Love*, 1969, oil on canvas, 162 × 130 cm. Rosengart Foundation, Lucerne.

137: *Reclining Nude and Guitar Player*, 1970, oil on canvas, 130 × 195 cm. Picasso Museum, Paris.

139: *Landscape*, 1972, oil on canvas, 130 × 162 cm. Picasso Museum, Paris.